Galerie Mezzanin, Wien, 2003

Wie auch in anderen Arbeiten von Alexander Wolff werden in der
Ausstellung in der Galerie Mezzanin die gängigen Formen der
Kunstrezeption in Frage gestellt, bzw. die Beschaffenheiten/
Strukturen komplexer System(zusammenhäng)e wie Galerie, Raum,
Möbel, Skulptur, Bild untersucht.
Mit Hilfe kunstgeschichtlicher Zitate oder Gegenüberstellungen
wird auf formale Traditionen verwiesen und deren gegenwärtige
Position innerhalb einer als neutral gedachten Rahmenbedingung
wie Galerie, Raum, Möbel, Skulptur, Bild untersucht.
Modell für räumlich- skulpturale Arbeiten sind häufig die
Malereien, die immer von einer vorgegebenen Bedingung ausgehen
(Rahmen, Bildträger(Leinwand), Farbe, Format, Hängung) welche
sich im übertragenen Sinn auf die konkrete Ausstellungssituation
als auch auf die Erwartungshaltung/ das Vorwissen des Rezipienten
übertragen lässt.
Als Konsequenz wird eine Frage formuliert: Was ändert sich an
der Rezeption/dem Begriff Kunst, wenn sich die formale Geste aus
dem und dem ergibt oder wenn das und das nebeneinandersteht oder
etwas wie etwas anderes aussieht.

Die Galerie Mezzanin zeigt in dieser Ausstellung Installationen,
Skulpturen und Bilder des deutschen Künstlers Alexander Wolff.

Alexander Wolffs Arbeiten stellen die gängigen Formen der Kunst-
rezeption in Frage indem sie Beschaffenheiten und Strukturen
komplexer Systeme und deren Zusammenhänge untersuchen.
Mit Hilfe kunstgeschichtlicher Zitate oder Gegenüberstellungen
wird auf formale Traditionen verwiesen und deren gegenwärtige
Position innerhalb einer als neutral gedachten Rahmenbedingung
wie Galerie, Raum, Möbel, Skulptur oder Bild analysiert.
Modell für räumlich-skulpturale Arbeiten sind häufig Malereien,
die immer von einer vorgegebenen Bedingung (Rahmen, Bildträger
(Leinwand), Farbe, Format, Hängung) ausgehen - welche sich wide-
rum ebenso auf die konkrete Ausstellungssituation, als auch auf die
Erwartungshaltung / das Vorwissen der Rezipienten übertragen lässt.
Als Konsequenz wird eine Frage formuliert: Was ändert sich an der
Rezeption / dem Begriff Kunst, wenn sich die formale Geste aus
dem einen oder anderen ergibt, wenn dies und das nebeneinander
steht oder Ursprüngliches neu in eine andere Erscheinung tritt?

Galerie Johann Widauer, Innsbruck, 2004
Dekoration des Funktionalismus – Dekor der Funktion

Text zur Ausstellung

Es scheint für mich in diesem Fall naheliegend und sinnvoll, sich über den Ausstellungstitel den künstlerischen Strategien des Berliner Künstlers Alexander Wolff zu nähern. Die sich im Titel entfaltende Dialektik führt vermutlich im Sinne des Künstlers zu Definitionsengpässen und einhergehender Irritation: ist es doch stets des Funktionalismus vorrangigstes Gebot sich aller Schmuck, Ornament- und Profilierungselemente zu entledigen, wobei jedoch Wolff´s eigens für die Räume der Galerie Widauer konzipierten und in Serie gemalten Bilder gerade Motive und Ornamentstrukturen der im Alpenbereich verbreiteten Holzschnitzereien zur Vorlage haben. Die verunsichernde Ambivalenz der in einer Zeile verwendeten Termini manifestiert sich zusätzlich in einer, beinahe der Höhe der Galerieräume entsprechenden und aus einer Vielzahl vergrößerter Dekorelemente aus Presspan bestehenden Skulptur.
Diese massive und dekorative Konstruktion bündelt Blickperspektiven, steht zentral in reger Korrespondenz mit den übrigen gezeigten Arbeiten und drehte man sie um 90 Grad, sie wäre wohl die perfekte Brücke zwischen formal Widersprüchlichem.
Dass eine künstlerische Position eine andere inszeniert ist in der heutigen, internationalen Ausstellungspraxis keine Besonderheit, dass aber diese aus dem Bereich des Tanzes kommt, ist ungleich seltener der Fall.
Das auf das Garagentor projizierte Video der französischen Tänzerin und Choreographin Alice Chauchat "quotation marks me" (2001) arbeitet wiederum mit Paradigmen der Moderne in ihrem Metier. Basierend auf zwei Schlüsseltexten, einerseits "The Art of Making Dances" von Doris Humphrey, andererseits "The No Manifesto" von Yvonne Rainer versucht die Protagonistin, Alice Chauchat selbst, beiden, sich grundsätzlich und vehement widersprechenden Ansätzen gerecht zu werden. Dabei das zu einen, was nach strikter Auslegung der Theorie unvereinbar bleiben müsste, gelingt Alice Chauchat mit den Mitteln des Tanzes und vor allem mit Erfolg. Diese Herangehensweise im Umgang mit der Moderne nach

konzeptuellen Schlupflöchern und verbleibenden Ebenen des Experiments zu forschen und Genre übergreifende Techniken mit historischer Sensibilität freizulegen, ist der produktive Verdienst einer jungen Generation von Kunstschaffenden, zu der Alice Chauchat und Alexander Wolff definitiv zählen, ohne das dabei das Präfix „post" übermäßig strapaziert werden muss, noch ausschließlich einem Medium allein eine selig machende Wirkung attestiert wird.

Nach vollendeter Projektion hebt sich das Garagentor für zehn Minuten und das künstlerisch inszenierte Galerieinnenleben tritt in einen spannungsvollen Dialog mit der industriellen Umgebung. Ein ausstellungsdramaturgischer Kniff, der die örtliche Exponiertheit der Galerie Widauer unterstreicht und die Ausstellung im Intervall in einen erweiterten Kontext stellt, in dem die Gesetzmäßigkeiten des White Cube außer Kraft gesetzt sind, die funktionelle Konkurrenz zwischen den gänzlich unterschiedlichen bzw. unterschiedlich genützten Räumen aber betont wird.

Der, den Raum zusätzlich unterteilende patchworkhafte, aus, auch im gezeigten Video zum Einsatz kommenden, im Textilen ähnlichen Kleidungsstücken genähte Vorhang funktioniert als ideales, symbolisches Bindeglied zwischen vergangener, dokumentierter Tanzaufführung und aktueller Ausstellungssituation. Frei nach Baudrillard „bedeutet das für den Gegenstand die Möglichkeit, über seine „ Funktion" hinauszuwachsen und eine zweite zu übernehmen, zu einem Element des Spieles im Rahmen eines universellen Systems der Zeichen, der Kombination und des Kalküls zu werden."(1)

Fazit: Einmal mehr entging der Künstler Wolff der selbst auferlegten Patt-Situation: Henne versus Ei oder richtiger „ Dekoration des Funktionalismus-Dekor der Funktion" durch mannigfaltige Intervention mit pluralistischem Medienvokabular, nicht ohne dem/ der Rezipient/in ein dickes Plus auf der ästhetischen Habenseite zu bescheren.

Christian Egger

(1) Jean Baudrillard – Das System der Dinge Campus Verlag Frankfurt/NY

Exhibition for an Art Lover, The Project Room, Glasgow, 2005
Christian Mayer & Alexander Wolff

The House for an Art Lover in Glasgow
by Charles Rennie Mackintosh

ART LOVER: (standing in the Oval Room leaned against the windowsill)
Art broadens the horizons of my experience and facilitates newperspectives on the world that surrounds me. But sometimes that doesn't work and then I askmyself, is this because of me and my own mental dullness or because of the incapacity of the art work to communicate with me?

ARTIST: (sitting at the table of the Oval Room and looking towards the window)
I will never never explain anything.

ART LOVER: (standing in the Dining Room in front of a dark wooden wall and next to a flower in a vase)
What if the artist was nothing special but simply an essential part of the society which has been and is and will be and has to be? Like the lawyer and the cashier and the bricklayer?

ARTIST: (coming up the stairway)
I've rarely found anybody in society to concede the necessity of my profession. My role seems to be rather uncalled for and forced. It's a niche that I have to create myself.

ARTIST: (standing in the Music Room, next to him sitting on a chair is the Art Lover)
In an ideal case knowledge about the engagement of the spectator helps me to get deeper into a more subjective and radical view on the things that I'm doing.

ART LOVER: (sitting in the Music Room on the piano chair)
I've always been jealous of the freedom of you artists. In the name of the art you are allowed to do what for others is forbidden. But maybe freedom isn't always such good fortune. I am glad to get up every morning and to know what the days schedule is and not having to choose one of a million possibilities.

ARTIST: (standing in the Main Hall leaning against the dark wooden wall)
Why should I think about you? It's not you that I'm interested in but the most complete expression of my sensitive and fragile ideas. The attempt to look at my work from your perspective evokes the most curious doubts in myself. This pulls the rug out from under my feet.

ART LOVER: (looking through the banister of the stairway)
But if the audience wouldn't exist, could there still be art?

ARTIST: (slowly walking through the Main Hall)
I see the world in a state where everybody is longing for communication. Art makes it possible for me to communicate. But if there is nobody interested in this form of communication, then art is pointless.

ART LOVER: (standing on the balcony, leaning)
But who, if not me, will pay for the privilege for you to dedicate yourself entirely to the arts?

ARTIST: (standing on the balcony, leaning)
I always hated dependency.
There is nothing more to say about that.

Galerie Ben Kaufmann, München, 2006

Emilie Renard, Paris

Cher Alexander,

Voilà donc dans l'urgence un email tardif qui servira de réponse à ta commande express d'un très court texte sur ton travail. Plusieurs possibilités s'offraient à moi et j'ai écarté d'emblée l'idée d'employer des formules trop généralistes, pourtant si adaptées à ce format. Ma réaction est donc plutôt d'appliquer une méthode analogue à la tienne, qui consiste à utiliser, même partiellement, une structure préexistante en l'adaptant aux conditions strictement matérielles de ce contexte précis. Aussi, mon support concret, (1500 signes), est-il destiné à donner en actes, une idée sur ta méthode de travail plus que sur tes œuvres, à l'aide d'une réponse circonstancielle, autoréférentielle, réalisée avec les limites brutes (de temps, de place et de moyen) qui me sont imparties.
Mais comme tu n'es pas seulement un artiste conceptuel ni moi un auteur réaliste, je ne me limiterai pas à l'énoncé des conditions d'existence de cette commande. J'userai donc d'un élément étranger, très grossièrement cité, plaqué, recomposé et choisi pour l'occasion, à ton propos. J'utilise donc les mots de Gerhard Richter dans une économie d'énergie, de temps et d'invention si caractéristique de tes procédés. Si ce jeu de citation peut paraître franchement académique, autoritaire et suranné, je l'utilise ici par affinité avec cette pratique de déplacement et afin de tester la validité d'un énoncé adapté à un objet qui lui est étranger : « L'art se fonde sur des conditions matérielles. […] Je n'ai qu'à agir selon les lois et les conditions qu'impose la forme pour qu'elle se réalise avec précision. […] Le dessein : ne rien inventer, aucune idée, aucune composition, aucun objet, aucune forme – et tout obtenir : la composition, l'objet, la forme, l'idée, l'image.» À cela j'ajouterai, sur un ton un peu forcé, « l'idée qu'une forme correspond à un message défini (et inversement) est naïve, mais nous identifions malgré cela, toutes les manifestations visibles et les associons, même vaguement, à tel ou tel contexte idéologique, géographique, historique ou quotidien. »

Bien à toi,
Émilie

Galerie Mezzann, Wien, 2007

BILL GRUNDY: I'm told that the group has received £ 40.000 from a record company. Doesn't that seem...er...to be slightly opposed to their antimaterialistic view of life?
SEX PISTOLS: No. The more the merrier.
BG: Really ?
SP: Es fällt mir schwer, mich damit abzufinden, dass Kunst nichts zu Lösung gesellschaftlicher Probleme beitragen kann.
BG: Well, tell me more then.
SP: We've fuckin' spent it, ain't we?
BG.Really?
SP: Down the boozer.
BG: *Really?* Good *Lord!* Now, I want to know one thing. Are you serious or are you just making me, trying to make me laugh?
SP. No, it's gone. Gone.
BG: No, but I mean about what you're doing.
SP: ...Mir scheint, dass ich das subjektive Bewusstsein dieser Landschaft wäre und meine Leinwand ihr objektives Bewusstsein. Meine Leinwand und die Landschaft, beide ausserhalb von mir, aber die letztere chaotisch, vergänglich, wirr, ohne logisches Dasein, ohne jede Vernunft, die erste beharrend, dem Gefühl zugänglich, kathegorisiert, teilnehmend an der Seinsweise, am Drama der Ideen.
BG: You are serious?
SP: There are two things that go on in art. There's getting to the essential material and a design that's inherent in the use of the material, and also an essential level of expressiveness, a precise way of saying something rather than a complicated way. Hemingway said about writing that a writer who has to go on and on and on and on about something wasn't sure of what he was writing about. That if he really knew his subject, he could say it concisely...
BG: ...and that's something you have to search and work and practice.
SP: I have difficulty when people make pronouncements about essential forms of being, because if things are essential, that means, that they don't change. Not to have the possibility of changing is frightening to me. I can understand the desire

to hold onto this view, because it makes things simpler. It makes it easier to act, in a way. It makes action much simpler. Otherwise people might tend to reflect more, and wonder what they're doing is viable or not.

BG: Beethoven, Mozart, Bach, Brahms have all died...

SP: They're all heroes of ours, ain't they?

BG: Really? What? What were you saying, sir?

SP: They're wonderful people.

BG. Aber Veronese, Rubens, Tintoretto, die Sie doch lieben ?

SP: Oh yes, they really turn us on.

BG: Well suppose they turn other people on?

SP: *(Mumbled)* That's their tough shit.

BG: It's what?

SP: Nothing. A rude word. Next question.

BG: No, no. What was the rude word?

SP: Shit.

BG: Ich pflege zu meinen jungen Studenten zu sagen: Sie wollen also Maler werden? Vor allem müssen sie sich ihre Zunge abschneiden, denn ihr Entschluss nimmt Ihnen jedes Recht, sich mit irgend etwas anderem als mit ihrem Pinsel auszudrücken.

SP: Ja, ich will wissen. Wissen, um richtiger zu fühlen, fühlen, um richtiger zu wissen. Gerade, indem ich der erste in meinem Handwerk bin, will ich einfach sein. Die Wissenden sind einfach, die Halbwisser, die Dilettanten machen halbe Realisationen. Nicht wahr, im Grunde sind ja Dilettanten nichts anderes als Leute die schlecht malen.(...) Ich will ein echter Klassiker sein, wieder durch die Natur klassisch werden, durch die Anschauung. Früher hatte ich wilde Vorstellungen. Das Leben! Das Leben! Ich führte nur dieses Wort im Munde.

BG: What about you girls behind...? Are you ...er...are you worried or are you just enjoying yourself ?

Fan: Enjoying myself. Not necessarily in the way that people anticipate. There often seems to be an expectation that the work will have a didactic aspect. But really it mocks didactism. Hopefully my work demonstrates the complexity of things, that to make any one kind of authoritative statement about the way things are is specious

BG: Ah, that's what I thought you were doing!

Fan: I always wanted to meet you.

BG: Did you really? We'll meet afterwards, shall we?
(Laughter)
SP: You dirty sod. You dirty old man.
BG: Well keep going chief, keep going. *(Pause)* Go on. You've got another five seconds. Say something outrageous.
SP: You dirty bastard.
BG: Go on, again.
SP: You dirty fucker.
BG: *Whaat* a clever boy.
SP: What a fucking rotter.
(More laughter)
BG: (Turning to face the camera) Well that's it for tonight. I'll be seeing you soon. I hope I'm not seeing you *(To the band)* again. From me though, goodnight.
(Today theme, Closing credits.)

Interview Sex Pistols Live on BBC, Thames TVs Today im Gespräch mit Bill Grundy am 1. Dezember 1976 mit Antworten und Fragen von Paul Cezanne, Henri Matisse, Charlotte Posenenske, Joachim Gasquet, Kenneth Noland und Renee Green.

Galerie Johann Widauer, Innsbruck, 2007
Manuel Gorkiewicz, Alexander Wolff

Transformationen des Alltäglichen

Die in der Ausstellung in der Galerie Widauer präsentierten neuen Werke der beiden Künstler Manuel Gorkiewicz und Alexander Wolff thematisieren Möglichkeiten einer Verbindung zwischen geometrischen Strukturen mit Elementen des Alltäglichen. Bei Manuel Gorkiewicz steht dabei die Divergenz der Materialität seiner Bilder mit Formen des Dekorativen im Mittelpunkt seiner künstlerischen Auseinandersetzung. In seinem großen Wandbild entwirft er eine monochrome Grundstruktur aus Quadraten in drei Farbtönen, einem gebrochenen Weiss, hellbraun und dunkelbraun. Kontrapunktisch überlagert er sie mit Kreiselementen aus Dekorationsmaterial. Mit großer Leichtigkeit macht er in seinen Bildern Veränderungen des Kontexts sichtbar. Der Bildgrund ist eigentlich Schokolade, die Kreisringe sind ursprünglich Dekor. Durch seine bildnerischen Strukturen lässt sich ihre Herkunft nur noch erahnen und doch schimmert in seiner Kunst die Leichtigkeit des früheren Verwendungszweckes durch. Auch bei seinen mit kupferfarbiger Dekorfolie locker umschlungenen Skulpturen im Raum gelingt es Gorkiewicz auf poetische Weise, die klaren Vertikalen und leicht geschwungenen skulpturalen Formen aus ihrer statuarischen Haltung zu befreien und ihnen eine fast heiter schwebende Leichtigkeit zu verleihen.
Bei Alexander Wolff hingegen ist es das Material selbst, das die Physiognomie seiner Bilder bestimmt, wie etwa in seiner Serie von Détournements, den aus verschiedenen Leinwandstoffen mit bunten Knöpfen zusammengefügten Wandbildern. Gestreifte Stoffe treffen auf naturbelassenes Gewebe, einfarbige Stoffe werden in feinen Abstufungen miteinander verbunden. Die Wand wird Teil des Bildes, sie ist gleichsam der Bildträger. Charakteristisch für Wolffs künstlerische Konzeption ist der Titel dieser Werkserie, détournements, Abweichungen. Formal präzise und koloristisch mit großem Gefühl platziert Wolff sein für die Ausstellung entworfenes riesiges Wandbild, das sich auf harmonische Weise aus rautenförmigen Elementen, einer goldgrundähnlichen, durch Material

der Baustelle in der Umgebung der Galerie wieder gebrochenen Basis und Elementen aus Spanplatten zusammenfügt. Ebenso schlüssig ist sein anderes Wandbild, bei dem er geometrische Elemente wie Quadrat, vertikale Lineaturen mit der aufgerauten Struktur der Leinwand in subtilen Farbschattierungen verbindet.

Die Ausstellung zeigt auf prägnante Weise, wie zwei Künstler die klaren Formen des Geometrischen durch die Leichtigkeit des Materials, Veränderungen des Kontexts und Überlagerungen hinterfragen und wie sie dabei eine auch inhaltlich konzeptuelle Wesensveränderung dieser nur auf den ersten Blick so vertrauten Formen erreichen.

Gaby Gappmayr

Galleria Laurin, Zürich, 2007
Détournements de mode

 It goes without saying that one is not limited to correcting a work or to integrating diverse fragments of out-of-date works into a new one; one can also alter the meaning of those fragments in any appropriate way, leaving the imbeciles to their slavish reference to "citations." Guy Debord, Gil J Wolman, A User's Guide to Détournement, 1956, see: Bureau of Public Secrets, Berkeley, USA, http://www.bopsecrets.org/SI/detourn.htm

 It was time for us to move on. We took a bus to Detroit. Our money was now running quite low. We lugged our wretched baggage through the station. By now Dean's thumb bandage was almost as black as coal and all unrolled. We were both as miserable-looking as anybody could be after all the things we'd done. Exhausted, Dean fell asleep in the bus that roared across the state of Michigan. I took up a conversation with a gorgeous country girl wearing a low-cut blouse that displayed the beautiful sun-tan on her breast tops. She was dull. She spoke of evenings in the country making popcorn on the porch. Once this would gladdened my heart but because her heart was not glad when she said it I knew that there was nothing in it but the idea of what one should do. 'And what else do you do for fun?' I tried to bring up boy friends and sex. Her great dark eyes surveyed me with emptiness and a kind of chagrin that reached back generations and generations in her blood from not having done what was crying to be done – what ever it was, and everybody knows what it was. 'What do you want out of life?' I wanted to take her and wring it out of her. She didn't have the slightest idea of what she wanted. She mumbled of having jobs, movies, going the her grandmother's for the summer, wishing she could go to New York and visit the Roxy, what kind of outfit she would wear – something like the one she wore last Easter, white bonnet, roses, rose pumps, and lavender gabardine coat. 'What do you do on Sunday afternoons?' I asked. She sat on her porch. The boys went by on bicycles and stopped to chat. She read the funny papers, she reclined on the hammock. 'What do you do on a warm summer's night?' She sat on the porch, she watched the cars

in the road. She and her mother made popcorn. 'What does
your father do on a warm summer's night?' He works, he has
an all-night shift at the boiler factory, he's spent his whole
life supporting a woman and her outpoppings and no credit or
adoration. 'What does your brother do on a warm summer's
night?' He rides around on his bicycle, he hangs around in front
of the soda fountain. 'What is he aching to do? What are we all
aching to do? What do we want?' She didn't know. She yawned.
She was sleepy. It was too much. She was eighteen and most
lovely, and lost. Jack Kerouac, On the Road, Penguin Books,
London, 1972, pp. 228-229.

 Liebe Melanie, hier also ein paar Daten und Fakten:
Die Ausstellung wird
„Détournements de mode"
heißen.
Gezeigt werden Arbeiten vor allem in der Art derer die ich
hier sende. (…) Das kam aus einem Vorhang, den ich davor
gemacht habe, siehe Email 2. Vor diesem Vorhang gab es andere
Vorhänge. (…) Diesen Universalismus dachte ich mit einem
Pattern zu kommentieren, das jegliche Form innerhalb eines
bestimmten Rasters, eines bestimmten Rahmens zulässt. Der
Rahmen war dann die quadratische Form der Einzelteile und
die mögliche Verbindbarkeit an allen 4 Ecken. (…) Das war der
alte Vorhang, und der neue kam aus einer Weiterentwicklung
davon. Jetzt nur mehr Rechtecke und Quadrate, (…), aber
auch als Hintergrund, oder Wand, oder Bild. Ganz besonders
interessant fand ich hier, nachdem ich das mit den Knöpfen und
den Schlaufen herausgefunden hatte, dass die Module chaotisch
arrangiert sein können (so wie oben) oder ein Muster bilden
können (hier Streifen, so wie unten) - die gleichen Teile! Gut
fand ich auch an dem Vorhang, das er die Beidseitigkeit hat, die
einmal die Konstruktionsweise zeigt und einmal von hinten nur
das Bild, welches entsteht. Das Material ist Baumwolle natur,
gebleicht und schwarz gefärbt und Leinen, also Grundstoffe/
Farben die als neutrale Bildgründe in der Malerei gelten. (…)
Insbesondere, wen man noch zusätzliche Gestaltungsprinzipien
einführt über die verschiedenen Stoffe bzw. Stoffarben hinaus,
wie z.B. ein gesprühtes Muster, gemalte schwarze Streifen
längs, gebleichte helle dicke Streifen quer, zentristische
Anordnung, Rotfärbung etc. Die Dinger hängen dann nur

mit Pins an der Wand (…) Wahrscheinlich gib es dann noch ein kleineres Wandbild, das diese Farbtöne und praktisch „neutralen" malerischen Ansätze von einer architektonischen Gegebenheit ausgehend entwickelt. (…)
A
Email von Alexander Wolff, Wed, 09. May 2007

Ein Künstler will seinem Bild eine bestimmte Stimmung geben, etwas betonen und aus der Umgebung herausheben, Bildpartien kontrastreich trennen, oder Tiefenwirkung erzielen. Bei überlegter Anwendung können ihm diese drei Farbkontraste dabei behilflich sein. 1. Der Hell-Dunkel-Kontrast. 2. der Warm-Kalt-Kontrast und 3. der Intensiv-Stumpf-Kontrast. Der Hell-Dunkel-Kontrast trennt Bildpartien. Je unterschiedlicher die Tonwerte sind, desto starker heben sie sich voneiander ab. Sie müssen dabei natürlich nicht so kontrastreich arbeiten, wie das in Egon Schieles *Baum im Herbst* der Fall ist, wo mit zusammengekniffenen Augen eine starke Schwarzweißwirkung erscheint. Paul Klees *Betroffener Ort* zeigt eine reiche Skala von Hell-Dunkel-Kontrasten, teils durch feinste Abstufung, teils durch harte Entgegensetzung erzielt. aus: Fritz Lüdtke, Malen Zeichnen Gestalten, Atlantis Verlag Zürich, 1988, S. 138.

We can first of all define two main categories of detourned elements, without considering whether or not their being brought together is accompanied by corrections introduced in the originals. These are *minor détournements* and *deceptive détournements*. Minor détournement is the détournement of an element which has no importance in itself and which thus draws all its meaning from the new context in which it has been placed. For example, a press clipping, a neutral phrase, a commonplace photograph.
Deceptive détournement, also termed premonitory-proposition détournement, is in contrast the détournement of an intrinsically significant element, which derives a different scope from the new context. A slogan of Saint-Just, for example, or a film sequence from Eisenstein. Extensive detourned works will thus usually be composed of one or more series of deceptive and minor détournements.
Guy Debord, Gil J Wolman, A User's Guide to Détournement, 1956, see: Bureau of Public Secrets, Berkeley, USA, http://

www.bopsecrets.org/SI/detourn.htm

Hey Melanie, wollte nur kurz schreiben, das ich höchstwahrscheinlich die komplette linke Hälfte der Galerie schwarz streichen werde, in so einer Vorstellung von Balance, da der Boden eh schwarz ist. Weiterhin entwickeln sich die „Détournements" in eine offenere Richtung. Es gibt jetzt auch welche, wo das Knopfsystem nicht komplett durchgezogen ist, sozusagen nur angedeutet, und es gibt welche wo der Stoff sich nicht mehr an dieses Modulformat hält. (…)
liebste Grüße,
A
Email von Alexander Wolff, Sat, 26. May 2007

Im Weiteren darüber nachdenken über die Tatsache, dass sich die Dinger jetzt von ihrer anfänglichen Konzeption lösen und freier werden, wird mir klar, dass das jetzt dann eher „Malerei" ist, und der Zugang dazu eine Methode um sie (die Bilder und die Malerei) eher inhaltlich oder konzeptuell zu begründen. (…) soweit,
A
Email von Alexander Wolff, Sat, 26. May 2007

Détournement not only leads to the discovery of new aspects of talent; in addition, clashing head-on with all social and legal conventions, it cannot fail to be a powerful cultural weapon in the service of a real class struggle. The cheapness of its products is the heavy artillery that breaks through all the Chinese walls of understanding.[4] It is a real means of proletarian artistic education, the first step toward a *literary communism*. Guy Debord, Gil J Wolman, A User's Guide to Détournement, 1956, see: Bureau of Public Secrets, Berkeley, USA, http://www.bopsecrets.org/SI/detourn.htm

Er glaubte eine Lösung des darstellerischen Problems auf analogischem Weg finden zu können. (…) um die Linie in ihrem Raumkontinuum zu lokalisieren, müssen sie um diese herumgehen, Länge und Winkel in Beziehung zu anderen Punkten und Linien messen und diese in einer gedanklichen Konstruktion des Raumes integrieren. Anders dreidimensional begabte Raumwesen. Sie haben einen Gesamtüberblick über das flächige Kontinuum und sehen daher die Linie gleichzeitig von allen Seiten her. Wie das dreidimensionale Auge eine Linie in der Fläche nicht als undurchdringliche Mauer wahrnimmt,

so wird das vierdimensionale Auge, vermutet Duchamp, einen dreidimensionalen Festkörper nicht als ein geschlossenes, undurchdringliches Hindernis erblicken, sondern gleichzeitig von allen Seiten und als transparenten Gegenstand. (…)
Was ihn faszinierte war die Feststellung Poincarés, dass das Euklidische Postulat „Die gerade Linie ist der kürzeste Weg von einem Punkte zu einem anderen Punkte" durch Erfahrung nicht beweisbar ist, dass Axiome prinzipiell keine Erfahrungstatsachen, sondern „auf Übereinkommen beruhende Festsetzungen", „verkleidete Definitionen" sind, und daher, so Duchamps Schlussfolgerung, auch völlig anders formuliert und visualisiert werden können. aus: Herbert Molderings, Kunst als Experiment. Marcel Duchamps „3 Kunststopf-Normalmaße", Deutscher Buchverlag München/Berlin, 2006, S. 24-25 und 89-90

In closing, we should briefly mention some aspects of what we call ultra-détournement, that is, the tendencies for détournement to operate in everyday social life. Gestures and words can be given other meanings, and have been throughout history for various practical reasons. The secret societies of ancient China made use of quite subtle recognition signals encompassing the greater part of social behaviour (the manner of arranging cups; of drinking; quotations of poems interrupted at agreed-on points). The need for a secret language, for passwords, is inseparable from a tendency toward play. Guy Debord, Gil J Wolman, A User's Guide to Détournement, 1956, see: Bureau of Public Secrets, Berkeley, USA, http://www.bopsecrets.org/SI/detourn.htm

Zusammengestellt von Melanie Ohnemus

Galerie Ben Kaufmann, Berlin, 2007

Das leere Subjekt des Künstlers

Man wird wohl nicht alt als Künstler, der von Liebe und Wasser leben will. So häufen sich die Entscheidungen rund um die künstlerische Arbeit, die kaum etwas damit zu tun haben, und trotzdem den Weg zum Werk bereiten. Wie Pontormo in seiner Chronik nebst seinem Werk seine Existenz bis zur Aufzeichnung seiner Mahlzeiten und Krankheiten wahrnimmt, lässt sich auch Alexander Wolff keine Ruhe damit sein Werken immer im gesamten Rahmen seiner Existenz zu befragen, und immer wieder zu beantworten. Seine Produktion ist ein fortwährendes Antworten, eine absolute Bejahung des Lebens. „Schon die Handlung, der Akt sich irgendwo hinzustellen und etwas zu sagen ist eine Behauptung" schreibt Jutta Koether. Die Behauptung ist also schon längst passiert, und was sie genau behauptet ist eigentlich egal.

Die mit dem Subjekt ins Leben gerufene Modernität nimmt Wolff als Grundriss, um seinen eigenen Lebensentwurf zu produzieren. Dass in seiner ersten Berliner Einzelausstellung gerade die Diskussion vom zentrierten Motiv und der All-over Komposition als Grundmotiv fungiert, sollte einen nicht überraschen, da es gerade darum geht, zu finden wie man da stehen kann, ohne eine Affirmation halten zu müssen, die sich in unendlichen Debatten verlieren würde. Im Medium Malerei führt Alexander Wolff einen aufmerksamen und vorsichtigen Dialog mit ihren Bestandteilen Stoff und Farbe, um sie, nicht wie etwa Stephen Parrino, zu überspitzen und zerstörerisch der Geschichte ins Gesicht zu werfen, sondern mit der freudigen Geduld, sie immer wieder zu kombinieren und zusammen-zusetzen zu Momenten, die wie Hochstände einen Ausblick behaupten und gleichzeitig Teil eines weiten Netzes sind. Patchwork kann man sagen, und damit liegt man gar nicht weit weg von einer Technik, die sich in der Not distanziert von dem bedient, was da ist.

Alexander Wolffs Werke sind vorerst mal richtig da, im Raum der Galerie ausgestellt, sogar inszeniert. Die Umgestaltung des Raumes folgt weniger einem vom Künstler entworfenen Szenario

als den Gegebenheiten vom Raum selbst: Kalter dunkler Boden, komplizierter Grundriss, Rohre und Unebenheiten. Dramatische Gegenstände, die die Werke aufladen könnten mit einer oder anderen Bedeutung. Wolffs Antwort ist kein noch weisserer Kubus, sondern eine räumliche Weiterführung seines Stils in den Raum. Seine phänomenologischen Eingriffe wie das Ändern der Bodenfarbe sind weniger eine Neutralisierung, als ein sinnliches Denken, die den Galerieraum in einem Ort anfertigt, der bereit ist, die einzelnen Arbeiten zu empfangen. Konkret bedeutet dies dann, dass die Umgestaltung der Wände mit Papierbahnen ein eigenes Anordnungsmuster für die Hängung produziert, welches Wolff mit einer Reihe von originalen Entscheidungen bespielen kann.

Alexanders Wolffs Malerei spricht nicht von einer Welt, sie schafft eine, die den Anspruch stellt formal und im Ausdruck offen zu bleiben und sich nie in einer Bedeutung festzulegen. In diesem Sinne kann man sie als absolut originale Arbeit betrachten, die das Erbe der Modernität, die Neuansiedlung des verfremdeten Subjekts, in schlichtester Weise als konkrete Praxis aufnimmt.

Yves Mettler

Federico Bianchi Contemporary Art, Lecco, 2008
Tutto accade una prima volta – niente di ciò é mai stato

The temptation to call Alexander Wolff a 'moving target' is strong. But that would be misleading, as it would imply some kind of specious cleverness, or defensive stance as if reacting in opposition to, when the choices he makes seem rather to be governed by a sincere and abiding curiosity.

Working for the most part on stretchers and walls, Alexander Wolff uses a multitude of techniques that recently include stitching and weaving together canvas and various fabrics, or attaching modular squares of fabric together via buttons in grid and other formations. Some of these fabrics are dyed in monochromatic scales, others are bleached, or found, or seem to be scraps from his studio. Wall painting, collage, watercolor, and recycled (painted-over) flea market paintings have also figured among his modes of picture making, as have acrylic and oil paint depicting abstractions, alternating patterns and other motifs. His 'palette' as of late has been largely a loamy, au natural affair, literally, in that he sometimes uses dirt in his wall paintings, and in terms of over-all warmth and tone, which is dictated less by personal taste, but rather by the materials the artist uses.

Unlike a great deal of painting, there is nothing really fetishistic about what he makes; his works seduce a lot less than they intelligently befriend. They frankly occur in textured folds of thought, which emerge in the material, an un-precious yet delicate sense of objecthood and visually articulated systems that he permits himself to violate. Although he works in a conceptual tradition Alexander Wolff is not exactly a 'conceptual painter,' as the work is not exclusively idea driven. He reserves the right to be as idiosyncratic as he pleases, working in a linear mode that not only incorporates, but depends upon experiments, mistakes and failures in order to fluidly, as opposed to fitfully, proceed (it should be stated that Alexander Wolff has also been known to collaborate on more purely conceptual projects, far removed from painting, in addition to making sculptures and also co-publishing an art-magazine as, if not more, protean than his picture making.) Eschewing the grand, chest-beating récits of painting, his pictorial practice could probably best be described as an accumulation of heterogeneous footnotes to a primary body of works (painting) that will never take place. As such, the more of his work you see — rather than unraveling like most 'pluralistic' practices — the richer and more coherent it becomes. Crucial to his working method is the constant expansion of his own parameters, and if he could be said to be consistent in any way, it is precisely through a commitment to change, should his curiosity require it— as it so often does.

Chris Sharp

Ökonomie und post-conceptual painting, 2008

"It's not about the shapes," said Georges Braques in 1911, "it's not about the colours, or the style or the novelty, it's not about that, but of course it is about that as well." This could have been his or any painter's exclamation at any time of art history. This is a vague theory. The idea that art is not all about itself, that l'art pour l'art is a dispensable concept, where happens more escapism and self-indulgence than social or political or historical responsibilty or contextualization, has been approved and adjusted by its reoccurance in history and its navigation away from and towards positions of sociopolitical significance.
The continuous discussion for the materialization of the artwork could be the so called post-conceptual. Why could the term economy play a superior role in the idea of post-conceptual painting?
Because the idea of art here tries to define its approach to all questions regarding painting from a standpoint that is integrating all concerns in a non-painterly way.

Craftiness, labouredness, labour intensity-ness, or
something looking so laboured:
A: To keep it pure and simple there should be no craft involved. But what if it makes it look better, it's aesthetics more compelling?
B: Then it is good.
A: But I don't want to think about composition and colour tuning all the time...
B:...which are basic elements of peinture....
A: ...and would like it possibly to be realised by anybody, leave out the personal brushstroke!
B: Than think better about your idea.
A: But where does the material happen if it's all mostly an idea? Composition seems unavoidable.
B: What's your problem with it?
A: I don't want to think about where something looks better than elsewhere. It seems to be such a graphic design issue, something designers know more about.
B: But you're making composition all the time!
A: Maybe one could construct a system of exchangable elements

in a 2- or maybe 3-dimensional system. It's more a relational display of different possibilities which all have the same relevance. Of course there is no general mind, I am subjective. Arbritaryness and subjectiveness are reliable tools to work with...
B: Then anybody's decisions aren't any better than anybody elses.
A: It's not about better or worse, it is a matter of relevance. I cannot discover a point of reference, if preferences for material or shape aren't transparent or relating to something generally understandable.

...es war ein Akt der Neugier. Auch jetzt bin ich das Opfer meiner Verhaltensweisen: Jedes erinnerte Faktum in der Masse der Fakten, aus denen ich in meiner mehr oder minder kontinuierlichen Art dieses Dokument konstruiere, ist ein Akt der Erinnerung, eine gewählte Fiktion; und ebenso bin ich der Macher dessen, was unerinnert bleibt, verworfen wird. Also muss ich pausieren, Übersicht gewinnen, auf den Brennpukt meiner Positur lenken, dahin, wo sie wirkungsvoll ist. Meine Neugier war ein Erschaffen des Bedeutungsvollen.

Try again: Welche Rolle spielt die Ökonomie in etwas, was post-conceptual painting genannt werden könnte?
Hierbei geht es dem Kunstbegriff vor allem darum, seinen Ansatz hinsichtlich aller möglichen Fragen innerhalb der Malerei von einem Standpunkt aus zu beantworten, der sich aus allen Frage-stellungen ausserhalb der Malerei definiert. Um mit Malerei souverän umgehen zu können müsste man sich mehr mit ihr beschäftigen als man über sie nachdenken kann, um nicht in malerischen Problemen die spezial-Idee aus den Augen zu verlieren.
D.h. die Mittel, derer man sich bedienen könnte, müssten die allgemeinst verständlichen sein, sich in den grössten common grounds abspielen damit keine Verschleierung innerhalb eines malerischen Spielfelds passiert.

Was gäbe es post-konzeptuell zu tun? Wenn Ad Reinhard das Ende der formal linearen, sich auf ihr Wesentlichstes reduzierenden Malerei eingeleitet hat, ist spätestens seit der Wilden Malerei der 80er Jahre klar das man ihr den Hahn nicht

zudrehen konnte. Es scheint immer eine Malerei zu geben, die ihrer Zeit angemessen ist. Es scheint immer die Möglichkeit zu geben, die Zeit in der Malerei zu repräsentieren. Die Ökonomie ist eben insofern verwickelt, als es darum zu gehen scheint, Ansätze in größtmöglicher Präzision vorzuführen. Gedankliche Vorschläge lassen sich in präziser Kürze am besten formulieren.

"Each of these works are as much of thought."
What else could be said ? It continues to make us think. Our thinking is being reflected by creating the surfaces for it. Therefore we maintain the search for them. Just what sort of an art „mirror" must
it be in order to reflect "nothing but the truth"? And what advantage might inhere in a straight-forward doubling of the truth ?

Vielleicht ist es unproduktiv von gut oder schlecht zu sprechen. Vielleicht ist es zu begrenzt, von Produktivität zu sprechen. Hier ist das Einzige was sicher scheint, dass es zu keiner Grenze, zu keinem Ende kommen soll und kommen kann.
Wenn man sich nicht damit beschäftigte: „ ...die verschiedensten Seiten des Nachdenkens über und demzufolgende Möglichkeiten der Malerei auf eine konstruktive, unverklärende Art und Weise zu formulieren..."
Gäbe es eine andere Möglichkeit? Könnte ich mich immer wieder in ihr Aussehen verlieben?
Es gibt keine Qualität in dem Bemühen etwas weiterzudenken, solange nicht alles Vorherige verstanden wurde. Was ist es dann? Und wer denkt weiter beim Malen in der Gegenwart? Worauf stützt sich die Beurteilung der Sinnhaftigkeit einer Produktion? Ist es sinnlos über diese Fragen nachzudenken? Ist die Alternative hierzu das Statement einer sich selbst erfindenden Sprache (um einer konventionellen, bürgerlichen, rationalen, kontextualisierenden Analyse zu entgehen) ?

... Today this kind of classic painter's talk can create a not completely unpleasant sensation of being in a fluid art time warp, with stacks of modern canvases, artists dead or alive and exhibitions flickering rapidly before the minds eye.

The treatise of the divided planes

Reste von Textilien die zur Herstellung von Bildträgern verwendet werden -
Reststücke von Leinen und Baumwolle werden aneinander und übereinander genäht. Wo eine Naht ist, bildet sich ein Strich. Der am nächsten am Material stattfindende herstellbare Strich ist die Naht. A seam ist eine Nahtstelle is a division is a line ist ein Strich ist eine Linie. The seams are organised functionally, the fabric is used in an economic way. The economic use of the fabric produces a specific and orderly look. The fabric weaving pattern is horizontal - vertical, so is the direction in which it tears. So leftovers have mostly the shape of rectangles, the different sizes can make them overlap in chaotic order.
If the fabric pieces were organized in a non-economic way, their addition would produce a more chaotic, random looking aesthetic.
Any pattern of seams could be seen as basic requisites to make a painting. In the usual stretched canvas the seams are avoided to produce the illusion of blankness.
In the two-dimensional world planes seperate from planes through colours or shadows, and where there are no colours nor shadows the planes can divide with lines.
Where lines define planes the planes have a relation with their neighbouring planes as if colours or shadows were used.
Who cares about all that? He knows, and he knows that we know, that for some time now abstract painting that claims to be just abstract painting or primarily concerned with its formal qualities has generaly been considered argued out of any viable existence, its appeals to a universal language, spiritualism or the sublime discredited.
There could be an unspectacular reason to make a painting. Seams and fabric, as lines and planes are part of every painting. To extend the content from the subjective to the general and then back to the arbitrary and hazardous which may be vague and unsteady but may reflect in their synthesis as much as the deconstruction.

Ihre wesentliche Bestimmung ist die einer Malerei, die keinerlei - und sei es ein noch so entferntes - Verhältnis zu einer

Welt ausserhalb des Gemäldes hat; sie ist eine Malerei, die tautologisch nur sich selbst zeigt, und die somit Malerei (als Tätigkeit und als hergestellten Gegenstand) in der künstlerischen Arbeit selbst reflektiert. Die KünstlerInnen beziehen sich auf einen geistigen Gehalt des Gemäldes wie das für die abstrakte Malerei der Moderne nicht mehr oder noch nicht selbstverständlich war.

Where the industrial world is full of colours in every utilisation, I wonder if colours would be a
necessity in doing a painting. The image of an artwork to produce a spiritual or sensational experience is not in any way dependent on the use of colors. Or differently said, if anything is wanting to be made or said, there is no reason why colour should be involved in this process, or even paint. Whatever painting can be or ever will be be, what will always be involved, is material. Materials which are elements in their apparitions as they are constituted through a certain appearance that mostly contains color already. As brown is an "abstraction" of the colour of the earth, the wood, sand, or just as the ideological mixture of green and red, it can never be as relational as its references, meaning that wood in its natural appearance implies a million of ideas and applications and historical references. To relate each paint the embedded materiality, where a black and white painting could be a painting of snow and tar would be seductive formula, not that every black and white painting has to talk about snow and tar, more that the depths that is implicated in the use of these two abstractions would embed an inherence which is as evident as in the mentioned example.

trudi, Los Angeles, 2008
My Exposure to this Exhibition is all by Chance

Hello ALEXANDER: My friend! Where did you go?

FRIEND[1]: I went out for a walk and I came across a couch. I thought about bringing it inside but it's pretty soiled.

ALEXANDER: Do you want help bringing it inside?

FRIEND: I think I'll leave it there for someone else.

ALEXANDER: While being here I've noticed the rubbish that crowds the streets, you know mattresses, wood, furniture. It's as though people empty their homes into the streets when they are ready to make a new one; it's a great resource for those who want to give the objects a second life.

FRIEND: Are you one of those people shopping in the streets of a city for new materials?

ALEXANDER: I believe I would be if I was permanent here, but I can't take a mattress home with me to Berlin. I could use some of the wood I see next to dumpsters though.

FRIEND: For what?

ALEXANDER: For lots of things, it's the economy of means. I also dislike the color of the wood.

FRIEND: Why do you care about the color?

ALEXANDER: The color is site specific. The wood is colored by dirt and therefore the dirt colors the city. There's no choice of color, it's just the color of Los Angeles.

FRIEND: It's a pretty elusive color to paint a city. Why not pay attention to the color of the soil in this planter?

Annie O'Malley

ALEXANDER: Because that is earth not the dust from the concrete. I enjoy the history of this concrete dirt; it is documentation of my visit.

FRIEND: You know a humbling renaissance is when you discover that those things that are astonishing to one are undoubtedly another's normalcy.

ALEXANDER: Oh come on man Los Angeles is dirty, dirt is not sacred, it's everywhere.

FRIEND: Well then nothing is sacred and that's why people throw out their beds on the street.

ALEXANDER: I guess so, my exposure to this is all by chance.

FRIEND: Mine too.

Westfälischer Kunstverein, Münster, 2008
Fragmente der Geschichte für Sie zur Wiederholung als
Performance

Alexander Wolff (*1976) setzt sich in seiner Arbeit mit den Bedingungen und Konventionen heutigen ‚Kunstmachens' ebenso sinnlich wie konzeptuell auseinander. Seine, die gesamte Spannbreite von der Moderne als überindividuellen Lebensentwurf bis zu den 1980er Jahren als Revival des Individualistischen aufrufenden, ebenso improvisiert wie klassisch wirkenden Bilder, Skulpturen, Videos und Installationen schaffen immer wieder neue Situationen aus dem Material des Gegebenen. Aus Bühnenbildern, Wohnungsausstellungen und Zeitschriften, die Wolff mit entwirft, spricht eine überbordende Energie und befreiende Neugier, die sich im Kern wieder um die Frage, was Kunst und Kultur heute sein können, bemüht.

Der Kunstverein hat Alexander Wolff eingeladen, die derzeitige, ambivalente Situation des Landesmuseums zwischen Abriss einerseits und 100jährigem Jubiläum andererseits zu reflektieren. Bei seiner ersten Begehung zur Zeit des Abbaus der ständigen Sammlung bot sich ihm die melancholische und doch spannungsvolle Stimmung einer Entauratisierung von Kunst und einer architektonisch-skulpturalen Situation, bei der Vitrinen, Rahmen und Reste von Ausstellungseinbauten gleichwertig mit abgehängten Exponaten zu sehen waren. Zugleich erschien der 1970er Jahre-Neubau wie ein denkwürdiges Relikt einer derzeit fortschrittlichen Avantgarde.

In der Installation im Ausstellungssaal des Kunstvereins nimmt Alexander Wolff nun verschiedene Spuren dieser Situation auf und überführt sie in ein ornamental und farbig kongruent gefasstes Gesamtbild.
Das monumentale Wandbild auf der abgetreppten Innenwand inkorporiert die Supraporten von Josef Albers, die sich hinter ihm außen auf der Fassade des Museums befinden; Fassadenraster und Kunstwerk werden die Grundlage einer vielschichtigen Komposition über fünf Wände. Mit den Farben gelb, rot und blau zitiert Wolff die Reduktion der Moderne und bricht sie zugleich mit Rosa und Gold wie auch mit der Verwendung von

Filz und Staub, die die Malerei zum Raum und Alltag ausweitet. Albers' Vexierbild, das zu einem Signet eines modernen Museums geworden war, wird weitergedacht und bereichert.

Eine Serie von Bildern bezieht sich auf die markanten Deckenmodule von Vortragssaal, Bibliothek und Kunstvereinsraum, die ebenso wie das Außenrelief charakteristische Gestaltungsmerkmale des Hauses sind. Wenn Wolff weiterhin Objekte aus seinem unmittelbaren Umfeld, wie den PVC-Boden seines Badezimmers in einem Haus, dessen Sanierung ansteht, oder die auf der Straße gefundene und bearbeitete Kachelwand in die Ausstellung einbezieht, geht er von der kulturellen Gleichwertigkeit dieser Dinge aus. Sie sind Zeugen des Umbruchs genauso wie das ‚Soester Antependium', auf das er sich in einem weiteren Bild bezieht, das bald in den historischen Altbau des Museums umziehen wird.

Eine Skulptur verarbeitet längliche, mit Leinwand bespannte Rahmen, die im Museum als improvisierter Lichtschutz vor die Fenster gehängt wurden. In den unterschiedlichen Wandfarben der Museumsräume bemalt, nehmen sie das Strukturprinzip der älteren Skulptur auf und entwickeln es weiter. Behelfskonstruktionen der Präsentation, unbeachtete Details der Architektur, aber auch bald im Depot verschwindende Werke werden Gegenstände der vielfältigen Montage, die wie der Raum des Kunstvereins selber, von einem bestimmten Kulturverständnis erzählt. Weiterhin verbindet sich die Situation vor Ort mit der Lebenssituation des Künstlers in Berlin, wenn er in seinem Video Tänzer in den Räumen des Landesmuseums mit Straßenszenen des Berliner Ostens kombiniert. Abbruch und Aufbruch werden so Momente einer Gesamtsituation, die weiterreichend einen Augenblick der ebenso individuellen wie allgemeinen Geschichte evoziert.

Carina Plath

Galerie Mezzanin, Wien, 2009
Ausstellung für leidenschaftlich an sich selbst Interessierte

Die Frage nach den Möglichkeiten von Malerei hat der Berliner Künstler Alexander Wolff auch für seine aktuelle Ausstellung in der Galerie Mezzanin wesentlich als eine von Kontext und Wahrnehmung ausformuliert. Seine charakteristische, konzeptuelle wie sinnliche Beschäftigung mit Stoff und Farbe steigert er dabei zu einer variablen Gesamtinstallation, in der sich Raum, Rahmen, Bild und Material gegenseitig durchdringen. Dies geschieht auf mehreren Ebenen:
Zu sehen ist einerseits die Serie Non Commodities, 2009, an den Wänden fixierte Stoffarbeiten mit Klettverschlüssen, die während der Ausstellungsdauer jeweils in sich verändert werden. Damit setzt Alexander Wolff seine Variation und Dynamisierung des Shaped-canvas-Konzepts fort.
Vollzieht sich hier die Idee einer Versuchsanordnung im Inneren des Werkes, wird sie andererseits durch die Präsentation einer Reihe auf Keilrahmen gespannter Arbeiten (alle Untitled, 20082009) im Verhältnis von Bild und Hintergrund verfolgt. Hintergründe bilden, teils Elemente der Gemälde aufgreifend, diverse Materialien, wie beispielsweise graue Farbe, Holz, Rauhfasertapete, Rigips, Kacheln, Fenster, Spiegel und gemusterter 60er-Jahre-Stoff aus dem Elternhaus des Künstlers. Die Choreographie von Alexander Wolff sieht vor, dass alle Bilder wöchentlich umgehängt werden, jedes auf einen neuen Hintergrund. Deren Formate entstehen entweder durch die industrialisierten Standards des verwendeten Materials, spiegeln die Maße der ausgestellten Bilder wieder oder, kennzeichnend für die meist ortsspezifische Arbeitsweise des Künstlers, sie beziehen sich auf die Tür- und Fenstergrößen der Galeriearchitektur. Dadurch kommt es regelmäßig auch zu vermeintlich unpassenden Kombinationen Hintergründe erscheinen etwa zu groß, werden komplett verdeckt oder bleiben ohne Bild.
Wie in den Arrangements und werkimmanenten Bewegungen der Non Commodities wird auch in der permanenten Veränderbarkeit der Ausstellung auf Instabilität insistiert. Die Malerei tritt in einen Reigen ästhetischer Konstellationen, die eine offene, vage und zugleich durchdachte, dichte Raumsituation kreieren.

Dass Alexander Wolff für seine Einladungskarte ein Graffiti fotografiert hat, überrascht auf den ersten Blick, löst sich ihm zufolge jedoch in einem wesentlichen Moment der eigenen Kunstproduktion auf: die Malerei, die durch ihren Hintergrund konditioniert ist beziehungsweise mit diesem verschmilzt. Licht und Schatten sind die Nahtstellen, die beide vereinigen. Diese Anwendung von Licht und Schatten ist auch das Grundthema der in der Ausstellung gezeigten Malereien, wo das Aus- oder Überblenden der visuellen Information einen Übergang zu einem anderen Material möglich macht. Die Naht, die Grenze zwischen Materien, Elementen, zwischen Dir und mir, die Qualität der Berührung, des Zusammentreffens, die Wahrnehmung des sich gegenseitigen Bedingens.

Galerie Ben Kaufmann, Berlin, 2009

Wir liefen gerade sein Treppenhaus hinunter als Alexander Wolff sagte, es ist so typisch für Berlin, dass die Häuser nie komplett sondern immer nur partiell renoviert werden, und wie man durch alle Schichten durchsehen kann. Neben uns war gerade ein frisch gepresslufthämmertes Loch in der Treppe, das sich durch alle Stockwerke zog. Man kann sich vorstellen, dass die Erzählung eines Hauses in solchen Schichten übereinanderliegt aber dann kommt der Presslufthammer und bohrt einfach einmal quer durch und dieses Loch ist dann auch Teil der Geschichte. Und aus den Straßenschichten wurden auch schon große Löcher herausgerissen, nicht zuletzt um Geschichte zu verändern, ihre zwangsläufige Anordnung zu durchbrechen. Der einzelne Pflasterstein bleibt ein erstaunliches Objekt, viel zu schwer um für etwas anderes beschaffen zu sein, als mit seinen Artgenossen einfach dazuliegen, aber zugleich so klein, dass es unmöglich bleibt, zu realisieren, wie solche Flächen wie der Bürgersteig einer Karl-Marx-Allee daraus geschaffen werden können.
Als Druckstein kommt er mir ideal vor, schwer und doch handlich.
Vorbei am Alexanderplatz, wo ich jedes Mal die letzten Sätze von Döblins Berlin Alexanderplatz auf dem großen Plattenbau lese, immer den Anfang verpasse und jedes Mal ist es eine Hundekälte auf dem Alex und nächstes Jahr solls noch kälter werden.

Der erste Blick auf die Ausstellung fällt in die beiden Fenster der Galerie. Sie sind komplett ausgefüllt von zwei Leinwänden, die genau so groß sind, wie ihre Glasscheiben. Die Bildseiten sind nach innen gekehrt und zeigen Abdrucke von Verbundsteinpflaster, gewalzte Frottagen von Straßenstücken. Von der Straße aus sieht man ihre Rückseiten, die vollständig mit kleinen Bildern verhängt sind, mit Druckproben, Stoffstücken, und Malereien, die sich dem Raster des Keilrahmens anpassen. Man kann mit dem Blick zwischen den bunten, stoffigen Teilen herumspringen wie in Schaufenstern von Geschäften für Allerlei, die erscheinen wie erinnert-entwendet aus zugehängten, aber doch halb

abgeräumten Auslagen wie sie typisch für Berlin der 90er Jahre sind. Der Eindruck von Schaufensterdekoration oder einer formalen Zusammenstellung löst sich aber schnell auf, denn die Bilder sind nicht einfach im Schaufenster ausgestellt, in Richtung Außen gestellt, es ist eher eine Situation, die da passiert, wenn eine der selbstverständlichsten horizontalen Flächen, irgendein Stück Straße, in die Vertikale gekippt wird und man sie von draußen und somit eigentlich von unten betrachtet, von der Straße aus, im doppelten Sinne. Dadurch bekommt man von außen den Einblick in eine Art Backstage, in mehrfacher Hinsicht: zum einen durch den Fundus an Probestücke und Fragmenten, die während der Produktion entstanden, wobei Stoffe und Muster Elemente ankündigen, die man in der Ausstellung teilweise wiederfindet zum anderen kommen mir diese Fenster wie ein weiterer Zugang zur Ausstellung vor, der nicht durch die Tür, sondern vielleicht eher durch diese Situation ermöglicht wird, die zwischen den ausgestellten Werken und dem Ort passiert. In der Assoziation zur Berliner Stadtgeschichte sind zugemauerte Fenster ein so starkes Bild, dass es bemerkenswert ist, wie wenig es sich aufdrängt und dass die Bilder auch ganz unabhängig von ihrer Installation gesehen werden können. Leinwand und Fenster konkurrieren fast miteinander in Größe aber auch mit ihrer Transparenz. Wenn die Sonne scheint, sieht man das Raster des Keilrahmens durchscheinen, das Muster sieht dann ganz anders aus, so wie sich die Straßenfarbe mit dem Wetter ja auch extrem verändert. Ist der Blick aus dem Fenster auf die Straße von innen also gar nicht verhängt, sondern findet in gewisser Weise statt, wenn man die Bilder betrachtet? Die Frottage macht mir die Materialität der Straße so konkret vorstellbar wie die der Leinwand für die sie nicht zuletzt eine materielle Strapaze bedeutet. Wie viel Realität hält ein Bild also aus, wie viel kann und soll es repräsentieren?

Das ist eine Situation, die sich durch die ganze Ausstellung zieht, dass die ausgestellten Werke sich in einer Situation befinden, die durch die Installation in der Galerie bewusst hergestellt und eben nicht geleugnet wird. Die historische Schicht, die mit dem Wandbild aufgedeckt wird, tritt in einer Weise zum Vorschein, die sie als Bild und zugleich als

Realität erscheinen lässt, indem sie die in einer bestimmten Zeit verorteten Zeichenhaftigkeit ihres Reliefs buchstäblich vorführt und indem zugleich klar wird, dass diese Dinge im Hier und Jetzt stattfinden und nur jetzt so gesehen und gemacht werden können. Auch hier ist es ein Raster, das den Blick auf die freigelegten Fliesen der historischen Schicht strukturiert, das nach einem Prinzip gegliedert ist und zugleich auf den gegebenen, mehr oder weniger zufällig so erscheinenden Hintergrund eingeht. Die tragende Fläche dieses Wandbilds ist wiederum wie eine Zwischenebene, die ihre eigene Transparenz besitzt, eine zeitliche vielleicht. Ist es im vorherigen Zustand die Galeriewand gewesen, eine im Sinne eines White Cube undefinierte Fläche, so wird nun durch partielle Durchbrüche die Fläche als etwas definiert, das auf ein anderes Vorher appliziert wurde. Diese doppelseitige Sichtbarkeit, diese ambivalente Definition taucht immer wieder auf und damit auch die Unsichtbarkeit, das Undefinierte.

Zwischen der durchscheinenden Kopfsteinpflaster-Lampe und einer Montage aus Tapetenstücken im hinteren Raum, auf denen wiederum Farbschichten weitere Montagen und Raster bilden, hängen auch Bilder, die klassisch als Bilder installiert und betrachtbar sind. Die Schnittstellen zwischen vorher und nachher, dem Gegebenen und dem Zugefügten, sind hier nicht entschlüsselbar, denn auch wenn Stoffe und Muster andere Zeiten und Herkünfte verdeutlichen, ist ihre Einbindung in jedes dieser Bilder so sehr Teil ihrer Autonomie, dass sie davon nicht mehr zu trennen sind.
Im Allgemeinen sträuben sich diese Werke davor, entschlüsselt zu werden, und das macht sie denke ich aus. So wie sie im gegenwärtigen Moment stattfinden, so setzen sie sich darüber hinweg.

Das ist eine Situation, die sich durch die ganze Ausstellung zieht, die zwischen den Arbeiten von Alexander Wolff und dem Ort passiert, das die Schichten und Elemente in den Arbeiten und dem Ort aktiv bleiben. Insofern hat die Ausstellung auch etwas theatralisches, ohne animiert zu wirken, denn den Dingen wird nichts Künstliches aufgesetzt, auch sind sie nicht als Repräsentanten festgefahren. Sie sind lose genug um sich neu

zu verbinden oder zu emanzipieren und doch bleibt ihnen etwas anhaften, was ihre Geschichte nicht erzählen muss, sondern sie durch vielschichtige Wiedererkennungswerte verkörpert.

Die Berliner Straße kam mir so großzügig vor als ich zum ersten Mal die langen Strecken über diese großen Stein- und Beton-platten zurückgelegt habe. Immer geradeaus auf der Karl-Marx-Allee. Das ist praktisch, wenn man Alexander Wolff auf dem Gepäckträger mitnimmt, der einem bei voller Fahrt plötzlich die Augen zuhält. Eigentlich ist das keine Ablenkung sondern Aufmerksamkeitslenkung auf andere Dinge, auf das Material, die Situation und die eigene Aktion damit und darin, also auf die Haltung, das Gleichgewicht und das Gefühl des Bodenbelags, denn wenn man die kantigen Doppel-T-Steine oder Knochensteine unter den Rädern spürt, heißt es, dass man vom Fahrradweg abgekommen ist. Zu eng, zu strukturiert fanden wir diese Steine in Frankfurt, als plötzlich alles damit zugepflastert wurde, wollten auch den Berliner Bürgersteig. Den kennt Alexander Wolff schon lange, kennt den Zustand vor und den nach der Wende und die dazugehörigen Straßenbeläge und so transportieren sie noch viel mehr Geschichte, als nur den Weg zum Straußberger Platz wie er heute ist.

Nora Schultz

Layr-Wuestenhagen, Wien, 2009
Birgit Megerle und Alexander Wolff

In Memory of Painting

Memory is isolated and put away in a painting container in the garage.

Can u collaborate with collaboration?

Painting is commonly seen as a solitary practice in the studio. We've chosen our tendency towards ornamentation as mutual affinity. Every picture rests better in one's memory than life itself. The Fabriano paper roll carries the slapstick comedy of flying waiters and whirling chairs, and the black pseudo-Thonet of steel with a fake bast mesh evokes the atmosphere of French bistros in the Majorcan studios. There's furniture all over - all over painting. We also want to participate in wavy-line painting! The young artist wants to create something people can desire or detest. His image will also be taken apart. Actors, activists, waiting viewers, silent critics: a life-size collage arrangement. Textile modules shaped like dress patterns can hold our image and theirs.

Everyone may decide individually whether or not to get involved.

Encore une fois:
Die Aufführung der Malerei im Werk von Alexander Wolff
von Elisabeth Fritz

Würde man die Selbstreferentialität der Arbeiten von Alexander Wolff und die dabei stattfindende Auseinandersetzung mit Grundbedingungen der Malerei, welche eine „bemalte Fläche erfüllen muss, um als Bild erlebt zu werden" ehe es „aufhört, ein Bild zu sein, und sich in ein willkürliches Objekt verwandelt"[1], nur als Formalismus, Reduktion und Tautologie verstehen, wäre das allzu verkürzt. So ist seine Kunst nicht nur durch eine intensive Beschäftigung mit den Bedingungen und der Geschichte des Auftretens spezifischer formaler Strukturen fundiert, sie ist vielmehr auch als ein kontinuierliches Durch-Spielen von Konstellationen und Choreografien von Bildern und ihren möglichen Bedeutungsreferenzen in konkreten räumlichen Situationen zu verstehen.

"A seam ist eine Nahtstelle is a division is a line ist ein Strich ist eine Linie."[2]
Der spielerische Charakter im Werk von Alexander Wolff zeigt sich nicht nur in den zahlreichen Wortspielen und kontextuell angewandten Zitaten, welche in seinen Texten, bei Performances oder als Werk- bzw. Ausstellungstitel zu finden sind. Die von ihm erschaffenen Anordnungen beruhen selbst auf einem spielerischen Zugang, sind sie doch experimentelle Zusammenstellungen von Formen und deren Wirkungen. Für seine großformatigen Wandbilder setzt der Künstler ausgehend von der jeweiligen Licht- und Raumsituation schwarze und weiße Farbe, sowie vor Ort oder im Atelier gesammelten Schmutz ein und ergänzt die Strukturen jeweils durch variierende andere Materialien, die mit dem Ausstellungsort zusammenhängen, wie zum Beispiel aufgesammeltes Straßenholz, Druckmaterial als Papier-Collé, ein freigelegtes Keramikrelief, Glasscherben oder gemusterte Vorhangstoffe aus seinem Elternhaus. Die zunächst einfache Logik der an der Wand geschaffenen Strukturen aus sich überschneidenden Linien wird dabei durch kleine Differenzen in den Symmetrien und in den Positiv- oder Negativsetzungen einzelner Flächen, sowie durch die Durchmischungen von Raum, Materialien und Farbtönen gestört. Es kommt zu einem Oszillieren des Blicks zwischen

einzelnen Elementen und der Gesamtstruktur. Nicht nur die sich über die ganze Fläche durchziehenden Linien verwirren durch perspektivische Effekte und Verkürzungen, auch die konkrete Materialität der einzelnen Elemente mit ihren zahlreiche Referenzen tragen zur Verwirrung und Verunsicherung beim Versuch der Wahrnehmung einer einheitlich geordneten Bildstruktur bei.

Durch die scheinbar nur lose befestigten Textilstücke aus Filz und Malereistoffen wie Baumwolle, Leinwand, Leinen wird der provisorische, zufällige und prekäre Charakter der Wandbilder zusätzlich verstärkt. Sie hängen schwer oder locker nach unten, bilden Falten, kippen zur Seite oder nach vorne – sie sträuben sich regelrecht gegen eine mögliche Decodierung als positive Form auf einer zweidimensionalen Ebene, brechen mit der Klarheit der den Blick leitenden Linie und verleihen der Gesamtkonstruktionen die skulpturale Qualität eines Reliefs.

Textilien kommen im Werk von Alexander Wolff jedoch nicht nur als Elemente der Wandbilder zum Einsatz, sie bilden auch eigenständige, von der Wand ablösbare Bildstrukturen in Form von Vorhängen. Das Zusammennähen von Stoffen als möglichst enge, dem Material entsprechende Verbindung, sowie die Naht als Ort der Berührung, verschmelzender und wieder auflösbarer Übergang von einem Teil zum nächsten fasziniert den Künstler generell als malerische Geste – so kam diese Technik zuerst auch für seine Bilder zum Einsatz. Als farbige oder gemusterte Stoffflächen, die vor einer Wand hängen, können Vorhänge zudem Aufschlüsse auf die skulpturalen und räumlichen Möglichkeiten von Malerei geben: sie haben eine Vorne und ein Hinten bzw. verdecken ein Dahinter, sie können gerafft, verschoben und an verschiedenen Orten eingesetzt werden, und durch die Befestigung am oberen Rand und die am Hinunter-Hängen ablesbare Schwerkraft beziehen sie auch die Decke und den Boden des Raumes mit ein. Im Theater dienen sie zudem der räumlichen und zeitlichen Markierung von Momenten und Situationen, der Unterscheidung zwischen Bühne, Spiel- und Realraum.

„... I was the author of the situation, not of the elements."[3]
Dass der Vorhang ein zentrales Motiv in Alexander Wolffs Arbeit ist, ist im Hinblick auf die „Theatralität" seiner ästhetischen Konstellationen und deren Eignung als Erfahrungsraum,

Bühnenbild oder Requisite nicht verwunderlich. So arbeitet der Künstler auch direkt mit Tanz und Choreografie zusammen, wie mit Alice Chauchat, für welche er ein Bühnenbild in modernistischer Formensprache geschaffen hat. Bei der Präsentation der Skulpturen und Bilder auf der Art Basel (2005) bleibt der Charakter als Setting zur performativen Benutzung und der unbestimmte Status der Objekte dabei spürbar.

Die Rekontextualisierung und Variation von Anordnungen spielt der Künstler immer wieder durch. Waren es bei der Ausstellung „Fantasien totaler Selbstpräsenz" (2005) in Wien noch Titel wie „Unmittelbarkeit der Darstellung", „Wiederkehr der Traditionen", „Sein Eigenes bleibt den Zeitgenossen unbekannt", „Welt ohne Zentrum" oder auch „o.T.", die beliebig und austauschbar auf verschiedenste Bilder angewandt wurden, so machte er für die Serie „Détournements" (2007) die geformten Bildträger selbst auflös- und veränderbar.

Die mit unterschiedlichen Techniken bedruckten oder bemalten Textil-Module suggerieren eine Vielzahl an Kombinationsmöglichkeiten der mit Knöpfen verbundenen „Puzzle-Teile". Ein modernistisches Verständnis von „Shaped Canvases", wo die Leinwand als Objekt mit einer bestimmten Form der innerbildlichen Komposition als Makrostruktur dominant übergeordnet ist bzw. die Mikrostruktur unmittelbar vorgibt, wird hier sozusagen umgekehrt und dynamisiert: Aus vielen einzelnen „geformten Leinwänden" mit rechteckigen, dreieckigen oder runden Anschlussstellen können immer wieder andere Strukturen gebildet werden, deren Gesamtform dann durch die unterschiedlichen Einzelelemente neu generiert wird. Passenderweise ist der Titel der Serie, der sich auf Prozesse der Umdeutung oder Umlenkung des gewohnten Einsatzes eines Mediums bezieht, aus der Terminologie der Situationistischen Internationale entliehen, wo die subversive Umkehrung oder ironische Verschiebung gewohnter Bedeutungen zur Schaffung von ungewöhnlichen Situationen mit künstlerischem Potential eingesetzt wurde. Somit kann hier Malerei durch ihre ständige Veränderbarkeit als eine Abfolge von konkreten Situationen mit kontextuell sich verändernden Bedeutungen und der Künstler als ein Autor von raum- und zeitbezogenen Konstellationen aus bereits vorgegebenen Elementen verstanden werden.

Für seine „Ausstellung für leidenschaftlich an sich selbst Interessierte" (2009) ließ Alexander Wolff schließlich die in all

seinen Werken inhärente Veränderbarkeit und Momenthaftigkeit auch tatsächlich aufführen. Dort zeigte er einerseits eine Reihe von mit Klettverschlüssen verbundenen Stoffstücken ("Non Commodities", 2009) und andererseits verschiedene auf Keilrahmen gespannte Arbeiten vor Hintergründen aus Farbe, Holzfurnier, Raufasertapete, einem Vorhangstoff aus dem Elternhaus, Kacheln und einem Spiegel, deren Formate wiederum Bezug auf die Fenster und Türen der Räume oder die Bilder selbst nahmen. Im Lauf der Ausstellung wurden die Anordnungen innerhalb der Stoff-Zusammenstellungen sowie die räumliche Verteilung der Bilder vor verschiedenen Untergründen wöchentlich vom Galeriepersonal verändert und neu gesetzt. Malerei wird dabei zur Inszenierung im Sinne einer „öffentliche[n] Herstellung eines vorübergehenden räumlichen Arrangements von Ereignissen, die in ihrer besonderen Gegenwärtigkeit auffällig werden"[4]. Ist eine solche Definition aber überhaupt auf Malerei übertragbar oder sollte man dann besser einfach gleich von Installation oder Environment sprechen? Dann würden wohl viele interessante und kunsthistorische Bezüge verloren gehen und wichtige Grundlagen missverstanden werden.

„… so wurde Malerei ein Flyer, theatralische Requisite, Stätte theoretischen Schutts, Musik/malerische Partituren, eine Tür, ein Gefühlsverstärker, Ort eines Wortspiels …"[5]
Der Diskurs über Malerei im Werk von Alexander Wolff findet nicht nur immanent, in der Analyse der abstrakten, formalistischen und nichtrepräsentativen Formensprache des Mediums statt, sondern auch an vielen anderen Orten. So arbeitet er als Mitherausgeber einer Zeitschrift, Musiker sowie in zahlreichen künstlerischen Kollaborationen[6], und setzt sich theoretisch mit der Vagheit und den Rekontextualisierungsmöglichkeiten von Zitaten und rhetorischen Floskeln aus der Geschichte der Kunst wie Populärkultur auseinander. In den Arrangements kommen grundsätzliche Fragen und traditionelle Topoi der Malerei, wie Repräsentation und Selbstreferentialität, Farbe und Form, Dekor und Funktionslosigkeit oder subjektiver Ausdruck und gesellschaftliche Relevanz ebenso auf, wie Aspekte der Performativität. „Theatralische" Mittel wie Rhythmus, Wiederholung, Instabilität, Variabilität, Fragmentierung oder

Offenheit werden von ihm bei der fortdauernden Aufführung von Malerei eingesetzt und zeigen diese als eine ortsbezogene künstlerische Tätigkeit, die sich durch allmähliche Annäherung zwischen Affirmation und Selbst-Hinterfragung nur in einer jeweils konkreten Situation ereignen kann.

Anmerkungen

[1] Clement Greenberg, „Modernistische Malerei", in: Kunsttheorie im 20. Jahrhundert. Künstlerschriften, Kunstkritik, Kunstphilosophie, Manifeste, Statements, Interviews, hrsg. v. Charles Harrison und Paul Wood, Ostfildern-Ruit 2003, S. 931-937, hier: 934.

[2] Alexander Wolff, „Ökonomie und Postconceptual painting", in: Zeus, Zeitschrift No.14, March 2008, S. 9.

[3] Michael Asher, Writings 1973-1983 on Works 1969-1979. Written in Collaboration with Benjamin H.D. Buchloh, Halifax/Los Angeles 1983, S. 209.

[4] Martin Seel, „Inszenieren als Erscheinenlassen. Thesen über die Reichweite eines Begriffs", in: Ästhetik der Inszenierung. Dimensionen eines künstlerischen, kulturellen und gesellschaftlichen Phänomens, hrsg. von Josef Früchtl und Jörg Zimmermann, Frankfurt am Main 2001, S. 48-62, hier: 55.

[5] Jutta Koether, „Große Erwartungen: Jutta Koether im Gespräch mit Sam Lewitt und Eileen Quinlan", in: Jutta Koether (Ausst. Kat. Kölnischer Kunstverein/Kunsthalle Bern), Köln 2006, S. 148-156, hier: 149.

[6] Mit Christian Egger, Manuel Gorkiewicz, Christian Mayer, Yves Mettler, Magda Tothova und Ruth Weismann gibt Alexander Wolff seit 2002 eine Zeitschrift mit wechselndem Titel heraus. Vgl. http://www.theselection.net/zeitschrift. Zusammen mit Christian Egger, Manuel Gorkiewicz und Markus Krottendorfer tritt der Künstler als die Band „Beauties of the Night" auf. In Kollaboration mit Erin Olivia Weber und Yves Mettler entstanden Performances wie "Classic Rock, Classics and Classical" (2008) und "And he doesn't even have the good Robert Smithson book" (2009). Für seinen Beitrag zum Ausstellungsprojekt „In Memory of Painting" (2009) arbeitete Alexander Wolff mit Birgit Megerle zusammen.

Federico Bianchi Contemporary Art, Milano, 2010
Visualizzazione

A piece of cloth torn from a tattered student protest banner found hanging in front of the Vienna Art Academy holds a portion of the U of "I LOVE YOU" from the phrase "RECLAIM (Y)OUR EDUCATION RECLAIM YOUR BODY RECLAIM YOUR BRAIN I LOVE YOU."
The students had painted the banner in a way that denoted the utmost practicality they had employed in their painting: a large piece of fabric, a paint roller, and paint, which is not black, but rather a moddled gray that seems to be the result of a combining of several paints to create the volume necessary for such a large statement. The texture of the street upon which they must have painted this phrase, the only space large enough to unroll such a canvas, leaves an imprint of the forceable context of their creation. Each work of art has embedded within it this archeology of practicality and the pathways to purpose in making a thing, an imperative statement, come to pass. In this situation, paint was simply the most direct medium possible for the students, and the directness of their action became an integral part of the directedness of their message. In this too, the architecture of the written word, the curves and straight lines of each letter were instrumental tools to their purpose. The statement must be made legible, to the extent that in the articulation of the curve of the U, no detours could be accepted. Had the angle been turned sharper, and approached that of a V, it's aim had failed. Therefore precision combined with practicality became their method of functional painting, whereas the unique texture of their situation was the aesthetic ghostwriter of this work. It is all inscribed in this painting, not only a legible message, but a legible intention. Painting this phrase, in a political sense, becomes a participation in a larger dialogue, the students' interjection in the world of what is written, said, and done, that they would like to change or to be an active part of.
The line of the U becomes a seam, straight and then curved, that is the joining together of two fabrics, the conversation between different textures.
The texture of a wall changes in accordance with its history, an archway becomes a window, a window becomes a wall, made from materials that did not exist when the original structure was built. Paint reacts according to these histories, and bending to the specificity of what the moment demands, becomes the visualization of making a work in this space and time.

Ali Hyman and Alexander Wolff

Federico Bianchi Contemporary Art, Milano, 2010
Visualizzazione

The little puppet theatre can be one of the places of the Idea, of the pictorial detail manifesting itself in the form of tangible image. It's the representation of a moment which is getting translated into a way of painting, into a formal idea giving the particular a chance to become universal through being art. Visualization in this case serves the purpose to present the act of painting. The formal - structural key element arises from different details: architectural (a building's frieze), pictorial (a perspective), sonorous (a chord). It's the intuition from which derives the possibility of representing music through a melody, art through a picture, the dimension of our lives in a fusion of all times and spaces in actuality. Everything leads back to an idea which can be material and particular at the moment of visualization, to rise afterwards towards an ideal model. The artist's intention turns into the process of intuition in painting, assuming substance and entirety in the form of a tangible image - as art.

The perspective of the viewer is guided by forms and colours that capture e.g. the structure of paint on a flag fabric from a student demonstration, the ornament of iron lattice from a window in Milano or the transition from white to dirt of snow in the streets. The works serve as a synthesis and analysis at the same time to the viewer's imagination, where the artist may use different materials (from acrylic to street dirt) to dilate the perception and add an aesthetic value to the pure and particular.

Visualization is an epiphany, the possibility for the spectator to see the dimension of the universal in the particular.

Federico Bianchi

Anne Mosseri-Marlio Galerie, Zürich, 2010
Mitzi Pederson, Alexander Wolff

Anne Mosseri-Marlio Galerie is very pleased to exhibit Mitzi Pederson (US, 1976) and Alexander Wolff (DE, 1976) together in their first two-person show. Threads, visual and artistic communication, creative interplay, mutual respect, conspiracy and friendship link the two artists. Their common interest in materials, planes, spheres, space and architecture are the basis of the installation in the gallery while their respective paintings and sculptures are exhibited within.

Pederson and Wolff's use of material and interest in fiber, colors, juxtaposition of tensions and textures are recurring in their individual and collaborative works. They investigate depth and dimensions, our interpretation thereof and interaction therewith. Spatial intervention and visual guidance within the gallery allows us to take a closer look at the finer elements and features of our environment, materials and their interaction with each other. Watch your step, see and sense the delimiters of space protruding from the walls, rising off the floor and parting the air with a fine line.

Line. How does one create a line and what does a line do? How and when do we see a line, the space above and below it, behind it, within it? Colors, lines, shapes and forms are perceived differently depending on how they are created and placed. The resulting boundaries are pertinent to this exhibit as Pederson and Wolff communicate and create the space together.

Mitzi Pederson's works created on site are spatial, meditative sculptures. Floating tension, gentle thin shadows, use of natural elements and delicate touches sharpen our awareness and focus on what is present. A natural balance on a wall contrasts with the large cypress trees springing to life outside. A simple twist changes the color intensity, angle, and triggers concentration and imagination at once. Soft color combinations of pink, green or blue cotton thread with wooden strips enhance closeness and distance - break lines.

Imagine a beautiful, simple, strong and intriguing voyage while remaining securely anchored; a breath of fresh air that releases tensions and induces calmness and concentration. The manipulation of materials create another space in our world.

Thread thickness, evenness, weft, edges, selvage, connections, stitch type are some of the critical elements to Alexander Wolff's paintings. In Untitled (Chlorox), 2007, the use of bleach to try to achieve the same color value on different types of cream, black and grey denim, brings forth the reflection of light. We constantly re-focus, adjust our attention to pinpoint the color pixels we are visually interpreting. The weave types, (temporary) permeability of dye and structures stitched together affect our vision. The fringes, fabric border, thread and touch of color invite us to perceive depth and imagine the essence of windows, as if we were looking at a building while blinded by the burning sunlight – a mirage. The typical 1970's architecture that was once appreciated and has now fallen out of favor is the inspiration for a painting of the ceiling of the Münster Kunstverein, Germany, showing light box, support structure, track light railings. Three dimensions in two, a 90-degree change of perspective allows us to see the ceiling structure as if it were a building façade or a Neo-Geo Painting.

Incorporating the gallery's columns, supporting cement ceiling beams in their installation allows them to delve deeper into architecture – a pertinent choice as the gallery is located in one of Zurich's first high rises – Hochhaus zur Palme - built by Haefeli / Moser / Steiger between 1959 – 64. This change forces the regular visitor to reexamine the space and works as they are exhibited differently. The invitation card was made in their studio and presents the juxtaposition of a child's drawing in front of an advertisement of a 1973 Morris Louis exhibit at André Emmerich's Galerie that was located across the street, on Tödistrasse. Pederson and Wolff honor materials, architecture, history and the interpretation of what we see and invite us to explore their vision.

Anne Mosseri-Marlio

New Galerie, Paris, 2011
From Beyond the Grid

Mathieu Carmona & Alexander Wolff

hey Mathieu une bonne nouvelle année! I hope all is well with you
guys. I guess we have to start working now on our collaboration
piece! Did you look at the plan? The two walls, which are already
marked red in the plan are the walls that are offered for us. I also
looked at some photos on the website of the gallery, and it seems to
me that the longer wall is maybe the better one, as it is the only
wall that goes from one side of the room to the other, without
interruption. It is framed in the best way... or what do you think?
The plan says it is 280 x 675cm. Do you have any ideas? Do you
imagine it being something rather free, or rather constructivistic, or
architectural? I feel very much open up for everything at this point.
You know how I mostly try to develop some sort of content
through having a closer look at the context, or the situation. And I
like patterns. And generally I don't really like too many colors.
Recently I made many works in pink, or shades of different pinks
and rose, but that doesn't have to apply here. Do you know this
gallery, have you been there? Maybe you should go there, with a
fotocamera, have a look around and introduce yourself, maybe
something happens, maybe you find something interesting? Maybe
you could also have a look at their storage, or walk around in other
parts of the building. Or maybe there are colors in the gallery space
that we could use (even though it looks as if there's only grey) ...or
is that house painted green? That could be interesting. Shades of
green with black and white,,....:) nice! Maybe they have a bucket of
that green paint in their storage? And maybe talk with them about
the set up time for making the piece, from what I understand it is
from 15th to19th. But I'm sure there's time for some little details
after that, too. And I hope it's okay for them if we nail or staple
materials on the wall, or paint with grainy paint? Ok, a plus!! A.
Well, about the piece itself, I think I should pop over to the gallery
and make some pictures and try to find some interesting architec-
ture elements or anything that could be useful to work with. That's
also the way I'm used to work so I think it could be nice and
relevant if we find some elements or colors that is specific to this
space and to use it in our painting. I also take a look at the plan and
I think that the longer wall seems to be the best one but maybe we
should wait to see exactly how it is. In my opinion, I think I would

prefer to make something constructivistic with repetitive motives, something quite simple but that could use architectural part of the room (to adapt itself to the shape of the top of the wall or anything else , we'll see with the pictures). But yes, I think that something quite minimal and repetitive could be nice. About the colors, I usually work with two-three maximum colors, most of the time black, white and red or some shades of grey, but if you want to use another color that's okay for me (but rose…I'm not that sure). Green could be an interesting option. I think that if we keep this system of two or three colors (including shades) that could have a strong visual impact all the more that the wall is pretty long (which is also a good reason to do something quite minimal in order to exclude any "rococo fresco effect"). Anyway I'll go the gallery tomorrow I think in order to take the pictures and send it to you. à bientôt. Mathieu. Bonjour Alexander, Voici les premières images ainsi qu'un plan que la galerie m'a fait parvenir ce matin. Je pense y passer demain afin de poser quelques questions et faire de nouvelles photos donc si tu as des interrogations particulières fait moi signe afin que je sois ton porte parole. thanks 4 the pics, they are great! The basement is also pretty interesting… but probably the upstairs space is more "in your face"…? or what do you think? I like the last room downstairs a lot. even though I think Ben maybe wanted to project videos downstairs, so that might be another reason why it's better to go into the main room. Any more ideas so far? e.g. materials? I think I do really like the dark green paint. the name of the show is pretty weird…je ne comprends rien! maybe that's something. greets! A. Hi Alex, I went to the gallery this morning in order to meet Marion, to take some pictures and to get a first impression of the space. I'll send the images to you tomorrow. Like you said, the upstairs space is really much better. An interesting thing, for example, is that you can see a part of the big wall from the street when you get in the gallery. It's like a big rectangle of almost 6,50 meter/2,3O meter high. The space is pretty minimal and lighted with neon on the ceiling. The basement is nice too but a little bit small and it looks a little bit like the typical French cellar with some kind of Arc on the ceiling which like you can see on the pictures. It's is very nice but I don't know if it will fit with our painting. The advantage of painting in the big room upstairs is that the lightning is better and the surface is really bigger. The green of the gallery is pretty nice, some kind of deep "schwarzwald"green. I think that could be a good idea to use it all the more that Marion told me that it the mairie of the 3rd

arrondissement who oblige them to keep this color because it was already like this during the 18th century of something. They must keep this heritage. You know, it some kind of historic building and if I remember well, the doctor of the king worked here. I like pretty much this kind of relationship between history and aesthetic. I'll get the keys of the gallery Saturday so then I will be able to go there and work anytime I want. I have also noticed some shapes or motives we could maybe use in our painting like the storefront front window for example. I'll send you everything tomorrow, as soon as I can. Greets. Mathieu. Salut Alexander, Here are some new pictures from the gallery space. I got the keys too, so from Saturday, I'll be able to go and work there anytime I want. On these pictures you can see the long wall we were talking about. I also take pictures of the doors that may be interesting to get motives. Maybe these half-circle shapes could be relevant to use. Well, I think I will try to draw some sketches and then send it to you so we could start exchanging stuff and talking about the project. I start sketching and I wait for your ideas and projects. bis bald. Mathieu. Hey, thanks a lot for all the input. Generally speaking: the timeframe to have the wallpiece finished by the 18th, when Ben comes to do the accrochage, sounds nice, but a bit stressful maybe. In favor of a really cool piece that we both have in mind, as I imagine, I'm sure it is possible to take more time, if we need it. Especially as the opening is 10 days later. I'm sure that's okay for Ben, if he knows that we're working! okay: I'm looking again at the picture of the storefront I find it striking to see that the storefront is basically a wood construction that is inserted into the stone/brick building I guess it is a typical French (Parisian) storefront, but I was never so aware of how they are constructed I wonder when they started to do it that way? I guess it also has to do with the glass, glass has to be framed by wood, stone is of course too difficult to carve like that, and wood moves in the organic way as glass likes it. These spaces are designed for maximum showing /show-casing of what they have inside, therefore a maximum amount of glass. It is a situation of a contemporary art gallery inhibiting a space that isn't designed originally to be a showcase for art. in this case they seem to be using the first room as their office, right? so from the street one can see the people working in the office, or packaged works leaning against the window. I guess the outside architecture implies a representative moment of trying to be "nice", classy, (elegant) etc. the distinguished green is a part of that. I feel there are many green

stores like that, is that so? so there is some kind of historical protection program going on, to keep the facades of certain house in the original way. they want to keep Paris looking like Paris has always looked, for what is is famous for. This reminds me of a conservatism which I encountered when I studied at the E.N.S.B.A., when they tried to set up the art studies as if it was 100 years ago. Do you know under which king, or when exactly this was designed? And you wrote the kings doctor was living there, or had his office there, do you mean in the same house? One idea that comes to my mind concerning the green wooden front, is e.g. - we could paint some wooden boards green, with green oil-based lacquer,(and first white primer of course, traditional craft style). I wonder what type of wood is used for this type of storefront. These boards could get attached to the wall...? (I'm interested in these wallpaintings to involve other materials then just paint. Also thinking of wood makes me think of some works which you made, where you painted wooden boards.) Another thought: generally speaking I wonder if that architecture provides enough of interesting history to instruct our artistic caprices to comment on it. I mean, we can also just give a shit. maybe there's more interesting things going on inside of us ...? What do we come up with, when there's NOTHING that we can hold on to - or refer to? Or, I guess, is there always something to refer to? In this case, I feel also that our friendship is a special ground that this work grows on. So what's going on with that? Nazi terror, Charles de Gaulle, Relations franco-allemands, Mai 68, Action directe & Baader Meinhof, New Wave, DAF et Clair Obscur, Berlin - Paris, Lili Reynaud Dewar, Bordeaux (vin), Techno etc? Maybe our friendship is an echo of the postwar heritage grace a de Gaulle et Adenauer, ...in some very translated way, but that is also reflected by the Show context, Berlin Paris gallery exchange. And you take part in the Berlin show, what's that all about? Et pourquoi tu t'es intéressé toujours beaucoup a la culture allemand? (et moi a la française.) Finalement nos pays sont des voisins! And Ben Kaufmann talks about the grid in the press release! So that's another completely different story.... Do have something to say to that? At this point I think maybe we could include our email exchanges as print-outs as material??? Maybe design them>... ? do you have time for all this...or shall we Skype - and record our conversations? Even though writing is nice a plus! A. Hi Alex, Concerning the time, it seems that to have finished everything for the 18th may be a little bit too optimistic... All the more we are not

yet totally fixed with what we'll do! And you're also right to say
that the vernissage is the 27th, so we have time. But I understand
quite well that Ben wants to know what's going on, that's the lesser
thing. So we could send him information "au fur et à mesure" We
have to work fast, but it's also important to think conscientiously
on the project and not to precipitate. Then concerning your remarks
: true that the green of the storefront (which like you said is in
wood like much of the Parisian storefront) is here deliberately to
keep the entire district looking the same as 100 years ago. This is
the conservative part of the socialist democrat Mayor policies
concerning the patrimoine of Paris. We are lucky as it's a nice
green, deep and dark and not any shitty color. Also, like you said,
the space is specifically designed to show contemporary art.
Marion spoke to me a lot about her will to work in an almost
perfect "white cube" and her difficulty to handle with spaces which
have a strong aesthetics identity. She tries to make her space as
neutral as possible which is a classical contemporary art exhibiting
statement. Like you noticed, the first space you see when you're
outside and inside the gallery is the working place. So when you
are in the street all you see is the people working on their macbook
with some stuff around them. Concerning the project: I like this
idea of painting boards of wood in green. This is more elaborate
and make the works richer of content and interpretation. It stands
between sculpture, painting, installation in situ etc... I'm just
thinking on one thing: this picture of the white door in wood which
is downstairs. I have sent to you some images. The boards of wood
are disposed in a way that makes some kind of stripes which could
make a motive for our painted boards installation. Maybe could we
make something quite minimal like a line of green painted boards
of wood disposed in stripes along the 6, 50 meter long wall. Maybe
always painted with the same green or a gradation, I don't know. I
really should start making some experiment on Photoshop to have
a more precise idea. Concerning the "french-german" thing, I think
this is a pretty hard topic to manipulate as long as it may seem very
quickly caricatural or something. Maybe it is more interesting to
focus on the idea of what belongs precisely to us as persons and
what we share except of the historic background of France and
Germany. I prefer the idea of the post-punk, industrial, cold wave
aesthetic. All the more that all this musicals movements are already
diverting aesthetics of modernity avant-gardes and linked, in a way,
with contestation movements in Germany and France. It may be a
good way to link an aesthetic quite minimal, opaque or cryptic with

all a cultural and political critic background and also with concerns about the aesthetic crisis in art. I like the idea of not being too discursive and to let the references appear in "watermark". Let me know what you think about all that. And about the press release, I always find it hard to stick to its statement but you can always find links between things even if they seem quite far from each others at first sight. And well Alex, for the email thing, I'm not that sure as my English is quite shitty like you can see and it would be a little bit embarrassing for me that it became public! But what do you want to do precisely: using it in the painting or publishing it nearby? Tell me. à bientôt. Mathieu. I just made some sketches in order to have an idea of what we may do with this idea of boards of wood. You'll find it maybe a little bit too minimal, I don't know but I thought that it could be a good idea to start exchanging some stuff in order to have some images under the eyes. Obviously these are just very first tests. Hi Alex. Here are some new sketches I just made. I used for them the logo of the famous indus-ebm band "Die Krupps". Maybe this triangle with three circles can offer an interesting form to use. It is very mysterious and it can remind something of the abstract avant garde in painting as much as esotericism or something like that. Maybe could we also make the triangle in wood and then paint the circle into them directly on the wall. Well, I don't know, these are just visuals tests and I wait for your propositions. So keep me aware of your research. I keep on experimenting on my own. à bientôt. hey! Sorry I wasn't faster in replying, this is once because I'm thinking and reflecting how to continue and didn't really have any new ideas but also because I'm working in the studio quite a lot at the moment and sleep there, too, and there's no internet. I wrote to Ben and that's okay for him if it takes us a little longer, he just wants to know what will happen and if we can show him some plans on the 18th it will be okay! Thanks for all the cool sketches. It helps already quite a bit to see what happens to the space when you apply different designs. One thing that appears in the drawing with the Krupps logo is these three circles: (which, as I found out, are the original logo the Krupp Industries. They represent the steel wheel that is welded without junctions (seams). That was the first original article of the Krupp dynasty.) Anyway, looking again and again at the photos of the space I notice that there are several circles or radiuses existing in the architecture of the gallery, in the storefront, and there are many in the cellar, and then also in the white wood door. So I think it's a good idea to use circles, and maybe we use the exact circle size

from the storefront? And then I think about the exhibition title and its grid theme. For me, this is more a suggestion to think about something that I haven't thought much deliberately - the grid theme. I guess it's true that I like the grid and that I use it quite often somehow. How is that for yourself? I like that it has a "democratic' surface, that all its elements, its contents appear at the same time. It is something that can also hold together very different things. And I like how it spreads out in space, and how it can always extend. It reminds me of waves of the ocean, or swarms of birds flying in clusters, or dunes in the desert, etc. here some grid pictures.--->> Now I have some ideas for a drawing in mind, give me another day and I can send you something! The idea for using the text that we're writing in our mails (in the wallpiece) is more a reflection to make the circumstances of our collaboration transparent , and I always think that this can be interesting for people who REALLY want to know. I would love it if we print out the stuff, also the pictures, and then loosely collage and decollage it in certain areas... if you like..? And what is behind the white door in the cellar? is this the door to the storage? I wonder if they would be d'accord that we use this door for the wallpainting, and leave the storage open. I would love that! But I don't know how yet. Or maybe we could use it as a stencil? okay, that's for today a plus! A. Hello Alex Today I must go to the gallery to take delivery of the artwork coming from Berlin. So I think take some measures of that circle and the storefront in order to have an idea and also go to the hardware store to take a look at the price of wood etc. As you noticed, the only striking form in the gallery space is the circle as everything is pretty austere here. So I immediately thought that it could be a good idea to use it in our work. Maybe it could be a good Idea to keep this idea of welded circles in order to make a veiled reference to Die Krupps. It's a quite minimal motive and it also refers to all an history of the working world, pop music and so on. Concerning the grid I like them also pretty much for the same reason as you: making explicit the surface, giving a feeling of anhistoric and non-chronological plan, revealing the object in one shot. It's a form without any end whereas it's necessarily lacunar. In a way it reminds me also of the theories of the fragment in early romantic literature in this idea of a limited form that can contain the infinity of the world. A very simple form able to give the idea of infinite. Concerning the text, I think that it can be a good idea to use our conversation but also in a fragmentary way. I think it make more sense with what I was talking about before. I didn't thought

about that, but this question of fragmented scripture or forms is central in my work and that could make sense to use it here. Behind the white door there is a small room in which they put away their tools. What do you mean using that door? Painting on it? Taking it off and bringing it upstairs? Tell me what you think. I will think about it myself. Maybe using it as a stencil could be a good idea. I don't know if they will agree but we'll see. I was also thinking about something concerning these texts. These last weeks I was working for Lili writing big texts on cardboard with stencils. I don't know if it's a good idea but maybe could we use the same process, it could be a wink to lili's work and the fact that it's her who introduces each other. But maybe she'll think it's more like plagiarism! Okay, so I just come back from the gallery with some new information. I joined in this mail pictures of the doors with the measures. And I went to the hardware store to take a look at the prices of wood I think the cheapest is this : 3 pine wood tablets 180/30 cm, thickness : 18mm : 19, 90 Euros there is also this : 1 tablet 200/300, thickness 18 mm : 11, 90 Euros 1 tablet knotty pine 200/50 cm thickness 18mm : 16, 90 Euros 1 tablet knotty pine 200/60 thicken. 18 mm : 19, 90 Euros 1 tablet knotty pine 200/40 cm thickness. 18 mm : 14, 90 Euros And then you have also wood that the guy cut for you, Fiber wood, 18 mm 23, 90euros/ m2, thickness. 22 mm : 29, 90 Euros/ m2 I think that you can find all the prices here: http://www.leroymerlin.fr/mpng2-front/pre? I'm also, thinking that my tests may be a little it too much "graphic" and not enough painterly...Anyway, these are just shitty experimentations, I think I'll try make it looks like a little bit more like a true painting. Send me your sketches when you'll be able to. HEY mate. Look, I made some sketches now. I took that idea of that Krupps logo and the way how you turned it upside down in the middle and simplified that a little bit. Also I used your idea of the wood being repeated as a single long shape. For my design I used the whole wall as a surface, then there is the frame of the storefront windows added to that, in two different ways: in the sketch 1 there are these groups of two storefront windows next to each other with a bigger space to the next group. that would be a good space to put the wood in, so therefore there are five pieces of wood. they have the thickness of the thinner intervals, the ones with, they kind of symbolize the wooden frame. In the sketch 2 the storefront window is repeated in even intervals, creating 9 spaces I between, therefore 9 pieces of wood. In the 2b I added the diagonals that could be an option, but doesn't have to be. How do you like it? It is not very

precise yet, as I don't have the measures of the storefront unit. this would be good to have, maybe you could measure it a) including, and b)excluding the frames? I think it makes sense to include that storefront, as this is the nicest detail of the architecture, or the most characteristic. This Krupps idea is funny. It directs the focus for me towards something that has to do with Industrialization, the main epoch of Paris growing, serial production, la tour Eiffel, Robert et Sonia Delaunay. Maybe we could assemble a catalogue of historic material to use as collage material? It's good because it brings us back to the origins of the grid! I could go to some libraries here and make some scans. I'm quite happy today with how things are going and I think it'll turn out great. If you could send me those measures, and if you like what I did, than I can make one or two more definite sketches which we can show then to Ben! ok? Dearest. A. Hi Alex, I'll go to take the measures tomorrow to send it to you as soon as possible. I'm looking at your sketches and I found them really great. I have to say that my favorite is the number two. It has some kind of classic and austere architecture look which I find very cool. My point of view is to keep some kind of austere aesthetic and not to fall into something too much "rococo". But I'm wondering how it will look like to add this board of wood on the wallpainting. I don't know if it wouldn't look like a collage or gratuitous... It's hard to know in advance. Maybe the fact that there would be nine piece of wood in a very repetitive way makes us avoid this risk but I don't know. I was also thinking that maybe we should keep the Krupps logo with the circles crossing each other to keep it maybe a little bit closer to the original one. Like that, it's almost unrecognizable, and In a way, I want to say that he will be necessarily unrecognizable but in order to keep the coherence of what it symbolize it would be better to keep it the original way. I find your idea of speaking about the industrial revolution through documentation very interesting too. I'm also very happy with how the project is going on, but as the time is running out I am more and more stressed wondering if I would have time to do everything at time! Maybe we should find a definitive form quick so I could start working as soon as possible! I'll send you the measure soon and it would be a good thing if I'll start drawing and painting during this week. Two (rough) tests I done with your sketches. Hi Alexander, I have joined in this mail the plan with the measures of the storefront door. Concerning the wall on which we would like to paint, I noticed something which may be a problem: there is an electric receptacle on it which I've

not seen before. There's also a little piece of metal but I think that we could paint on it. But concerning the receptacle... I join you the picture so that you'll see by yourself. Anyway, I keep on drawing sketches, but I really think I'll have to start painting tomorrow or the day after as the vernissage is the 28th!!! The ideal would be to make the sketch in the exact proportions of the wall so I'll just have to report it and not to make crazy scientific calculation. And concerning the collage of documentation, I was also thinking that it could be a good idea to join pictures from bands or artwork of albums with the images concerning industrial revolution. I join you some images too. But we have to hurry! Oh, And I was also wondering if we may leave some surface white. Maybe will it solve our "electric receptacle problem". So, Here are today's sketches (it seems that you'll have a lot to read and to look at today!) I have taken your drawing and just added back the die Krupps logo with the crossed circles and then putted colors on it. There is a version without white, a version with the white of the background wall and then a version with white and collage (I used the same Technik as the wall painting I made together in Ben's gallery last time). You have also a really really rough test version in the gallery space. Tell me what you think. I particularly like the "crossedcirclecollages.jpg" version. Are you online now? can we talk on Skype? I just tried to contact you there. My Skype name is anders_wols I'm online I'm just confused that that door is so high, it's higher than the space itself, I'm not sure about your drawing: is the whole height 287cm, or is it 287 + 40cm? I'll start the drawing with exact measures later, so the painting can start tomorrow! Hi Alex, I just added you to Skype. I think I'll be only all day long if you want to join me. (I just have to give keys to Lili in the afternoon, but then I'll stay here) Concerning the drawing, it's true that it was a little bit ambiguous. In fact the whole height is 287 cm. And that's also true (sorry I didn't thought about it sooner) that the storefront door is higher than the space in which we will paint. It seems that it lacks something like 7 cm... Maybe can we just change a little bit the proportions? I wait for you to connect. Mathieu. Hey!! Here comes the final sketch! I hope.... The scale is 1:10, so if you print it out in 100% (Maybe on 4 A4 sheets), it should be very helpful. But I've also written all necessary measures into it. In a way it is very easy. I didn't have time to paint it now, I will do that tomorrow and then send it over again, but it's not so important because you can fill out the fields however you like. But the drawing will already take you some time...:) If I was you, I

would probably use that string tool that I always use, in English it's called "chalk line" I'm attaching a picture, they will have that au Roy Merlin. And I guess you need one person to help. As you can see in the drawing, I had to move the bottom of the storefront 4cm down, to fit the little half circles into the space. The other option would be, to let it begin at 40cm instead of 36, and then to cut it off at the top. I would be interested in making a drawing of that possibility, too, but maybe you don't wanna wait anymore...or..? n any way you could start with drawing the triangles. Concerning the size of the circles: it happened by coincidence, that the size of the circle that I chose, created the effect that there is one circle at the same height throughout all three triangles. I really like that! About the collaged part: I'm not totally convinced by the music stuff as it is now....I know you really like that, but it's too many different things. It would be interesting, if it was concentrating on pop aesthetics that refer directly to the historic industrialization. Among those pics that you have sent, I can see that in the SPK picture, and in the yello DAF cover, all the other ones are really something else. I was thinking more of that original material as what I'm sending you here in the attachments (just some examples from the internet). But yes, we can mix some pop stuff into it, but then it should also really be within the industrial aesthetic, and there shouldn't be names or anything. That's too flat, too one-liner. let me know! so our materials are: 1. the green of the store front 2. different mixes of that green with the white wall paint . different mixes of that green with black 4. the white wall 5. Black 6. the print outs of all our email conversations 7. the picture collage parts 8. the green painted wooden bars. Great! let' fetz! no problems with the electric receptacle , you just leave that field empty, or you take off the plastic part, close it with tape while painting over it, and then remove the tape and put the plastic part back on, looks really cool! Cheers. A. Hi Alexander, I started drawing today and it's going on quite good. But it seems that the measures of the space are not exactly the same as on the plan. the walls are not perfectly flat so I had to do some corrections. I think that the correct measures are something like 6, 74 m/ 2, 77 meters. It would be also a good thing if you tell me the measures you prefer for the wood board so I can go and buy them tomorrow with Ben. Everyone seems here to have enjoyed our project and liked the pictures I showed so I think it will be great. Now I wait for your sketch and last measures. I'm going to the gallery tomorrow in the morning. à bientôt. Mathieu. here it comes again! Ok, everything stays the same basically,

despite the slightly smaller measures, except that you move the storefronts 4cm up, so all the measures +4, it looks cool when it's cut off at the top I think, you agree? And the woods are 7 cm wide, (like the original frame) and 253 long (249 +4) I would have filled out more fields but had to send it now, too much white like that/ if you have questions, Skype me! ok? A. Hi Alexander, Things are going quite well here and I'll be able to send you pictures of the painting quite soon. I think that, the painting would be finished maybe in two days or something like that. Then I'll have to solve the problem of the way of fixing the wood on the wall. I just wanted to know if you had collected any images to stick on the painting and how would you like it to be. I mean, maybe the best is to mix different images on the same page and then to stick it in the different shapes of the painting. à bientôt Mathieu. Here are the first pictures of the wall. Don't worry, it's not finished yet but it's progressing quite well. Hello my dear, Thanks for sending the images along. It looks fuckin' great man! It's going to be really cool. The only thing that I would suggest is to mix additional tones that intermediate between the highly contrasting planes so that there are more in-between tones. So here comes the collage stuff. It's all from books about the industrial revolution. It is cotton workers & factories, letter setting factory, the oldest iron bridge of the world in England, other prominent early steal bridges, worker ghettos, Bristol burning, the gare st. Lazare, the caricature of a Paris house after the Haussmann Paris reorganization plan, Joseph Paxtons Chrystal Palace, wallpaper printing etc. I would proceed as follows : print out all the pictures 5 x each on A4 (you should have then 100 sheets which might be enough), on a laser printer, cut all the white away, or tear it away which also looks cool... then use wallpaper glue and collage them into the fields overlapping each other so that the photos merge into one another. its good if it's all pretty wet, then the print color gets dissolved a little and the grey washes from one sheet to the next. Try to get it as flat and stretched out as possible, even though the paper makes wrinkles, of course. I'm curious what pictures you will add...? I hope the wall is not getting too crowded... make sure to leave enough white space and space for the collages and also the email collages. Have you printed those out already? I would also print them also several times so you have enough to work with. Visually I imagine them as text blocks where you can't really read the whole letters, but you get an idea of what the communication is all about. Collage -decollage style. Have fun! Best A.

Studio Sandra Recio, Genève, 2011

The gallery Studio Sandra Recio is pleased to present the first solo exhibition in Switzerland of the German artist Alexander Wolff. The exhibition consists of two new series of works, each dealing in different ways with the possibilities of painting as a means for connecting matters of biography, representation and context through material and form. Through this practice, an unique pictorial vocabulary emerges through a formal dialogue between the artist and the local situation.

For the first series of works, the artist brings into play a technique that was previously applied solely in his wallpaintings: the use of papier collé as painterly material. A set of frottages, made on fabric from old curtains in the artist's childhood home in Southern Germany, serves as starting point for the new pictures, taking their form from the bronze entrance door, made in 1958. The house has recently been abandoned by the family, making these traces time-stamped material evidence of a biographical period. These frottaged forms become windows to the process of painting carried out during the artist's stay in Geneva. Printed-out images from the artist's studio and temporary habitations in the city as well as environmental impressions of Geneva focus attention on the circumstances of artistic production, as well as upon the collaboration of biography and context in artistic production and the resulting amalgam of ornamental motifs and textures.

The second series of works, called "double frames", juxtaposes a collection of decorative plastic picture frames that the artist purchased at 99cent stores in Los Angeles, with painted motifs dealing with the history and construction of ornaments and patterns. This slightly ironic execution of postmodern process, where different historic styles are combined, brings forth a thesis that might be considered a prevailing proposition of Alexander Wolff's work: style is a mix between the subjective statement and appropriation, and always makes reference to a specific context.

In *Reference Library* the artist shows a selection of books from Simon Studer Art, an Art Consulting Company adjacent to the gallery. These books are now removed from their original place in the library shelves and are made accessible to the public and can be read it in the exhibition space.

Outside the gallery space, the work *Tapisserie Freihafen*, hung on the Free Port's corridor, seems to make reference to the formal vocabulary of minimal art, while it is actually relating to a site specific detail by tracing the architecture of the building back to its origins of construction: the wooden casts of the concrete walls.

Steve Turner Contemporary, Los Angeles, 2011
Matt Chambers & Alexander Wolff
Fragilee Hors devors

Certain artists refuse to say anything about their stuff, or they would say that this is not their work, their work is in the studio. Who's gonna read this text anyway. Ideas take on different shapes, a joke can trigger a painting - many ideas that we have came out of language. The works are not directly and only related to painterly discoveries, they maybe get talked out first and then painted. But painting can never be used for something - its always just ittself. Not uncovering the reference point. Paintings in disguise. Figueroa it out zourselves. The connection between what we painted and what we talked is back and forth. I'm trying to express this as truthful as I can think. Sometimes I wanna take out the affirmative sound out of this conversation and make it sound more private, or get closer to poetry, being at home in what language can do. But it feels rather akward anyway.

Why did we start to collaborate?

I did collaborations before.

I wanna make figurative paintings too.

Empty primed canvases, oil paints and brushes flying around everywhere in your studio when I came for a visit and your friendly invitation if I'd like to paint something,
Which I did right away, and then we did a few paintings and had funny conversations and then I suggested we should make it a collaboration and you agreed after a few days.

I think I agreed sooner than that.

It's about doing something together, getting to an unknown place etc.

I agree with that, I have always enjoyed the notion of "artist-as-explorer". And for me, I had lost my desire to make films almost exclusively because of the collaborative aspect, and part of that was because working with so many other people, so many checks

and balances, so many focus groups, I felt I couldn't see my own vision or hear my own voice in projects. Somehow the timing was right for this, I was ready to invite some other opinions into the studio.

Why do you always paint the same size?

When I had started making paintings I worked on different sizes, but I didn't know how to paint, and choosing this large size loaded with connotations outside of painting I was able to surrender to the act of painting. Decorating wasn't enough, I could never be in control of a painting this size because of its proportions relative to my body and because as a painting it functions so awkwardly (size-wise) by itself that it removed itself from any desires of making the perfect painting. As a size, it became a verb, demanding action from me.

Why haven't you collaborated b4?

Can u collaborate with collaboration?

Well I did the little gallery TRUDI, which felt like a collaboration while I was doing it simply because I was hardly a gallerist (in hindsight, it was my art school) and then I started making collaborative/collective drawings, but the reality was that the ego's I was around made it tough, people's time is always short, and my collaborative dreams were extremely naive.

And yes of course, no man is an island.

Maybe we haven't collaborated yet, maybe we're never doing anything together.

My idea of you is in the studio with me. Is it not the same for you? It's like a third component in the relationship that normally is just me and the work. You, me and the work. It all circulates around the center of this triangle.

The studios are extensions of the me or the you. When the studio burnt down this extension was missing. No studio - no art - no artists.

I used to make art in my home before i could afford a studio. I 've discussed with friends the pros and cons of working at home. I like that life works its way into the work at home and they are floating around between all the other stuff. It's more organic material and less commodity product.

How do you relate to the studio, how important is it for your practise.

Do you care about the works that we're making - as paintings?

In general, I don't care about paintings, maybe I care about art, I definitely care about ideas, and these paintings seem loaded with ideas. I truly care about the conversations and arguments we've had, and that's what the paintings are for me. Oversimplified but a child is hopefully a manifestation of the love between the two parents, not always, but hopefully. That seems to be the case here.

Do you agree? Do you see us as parents? I know I had used the metaphor that our collaboration was like (or I wanted it to be like) a business, in the sense that we were the laborers applying paint, but then we became the board of directors and made the best decisions for the work separate from the painterly passion. Do you agree with this metaphor, or is there another metaphor that works better for our role as dual-creators/collaborators that separates this work from your individual practice?

The parental metaphor worx 4 me. But I tend to love my kids. I care about and examine every detail of them - in my individual practice. I keep loving them whenever I see them. They interest me how they develop their own lives. Or after a while I don't necessarily understand 100% where I was coming from, and that's interesting, too.

But at the same time the metaphor stays a metaphor. As a matter of fact we're making art pieces together- or not together - so far paintings, works on paper, a video is coming along. I like that all of these products have to be completed, finalised, brought to an end in some way (which makes them different from the relation-

ship to children). The moment of deciding when a piece is done is really different in our collaboratice practice, it's sometimes arbitrary, sometimes by agreement, sometimes a result of defiance, insistence, or even persuasion, or it's just decided by in whose studio it ended up.

I also like how you noticed that people don't go to parties in Los Angeles, that artists' don't congregate and have dialogues; I saw our conversations in the studio and the desire to let that dictate the work as something quite special for Los Angeles.
How do you see what we're doing in the context of how this city (and maybe even this artworld) functions?

I am not quite sure about the impact of the city, but i wanna say: Los Angeles is famous for its insulary, parallel existing, spread out accumulation of specific energy zones, and I guess what we're doing and talking in the studio is making one of these energy zones. I guess there's less interference and close comparison and competition than in other cities. We're breeding over our conspiracy in a pretty undisturbed way. At the same time we're connected with the other centers like NY or Berlin, and we know and keep in touch with what's going on over there. These conversations are also like a check test with which we explain ourselves to one another, like checking each other out and getting to understand difference or something.

How would you describe your contribution in our collaboration in contrast to mine? Or how would you describe our individual roles in this?

Is there a difference? Each time we meet it seems the work and the way we work is different. I don't completely know if we have defined roles, which I really enjoy. You know, it's not like one of us is the good cop and the other is the bad cop. We both like to poke at what we see as the others aesthethic weaknesses, but idealogically we're quite similar. I mean we dislike the same artists. Even our roles with the works shift between the different pieces, and as you had predicted people ask who did what, and furthermore I like to confuse this (and it seems you do as well) by mimicking what we see as each other's marks.

At least its' comforting to me to know that we've both ruined about the same amount of pieces.

Do you see us as defined yet? Who's the surrogate?

I don't think we're poking at the others aesthetic weaknesses, I don't think there's such thing as aesthetic weakness, I prefer to believe that you and I do the things hopefully intentional and conscious. Weakness happens elsewhere, i think more in the area that you call ideological, or conceptual; like you could say to me: "this attitude here doesn't make any sense, because...", and you might be right. Or I could say: "Well, if you say you see this like that, why don't you do it that way?" etc.

This might be what collaborations are good for, we become aware of the strategies (work methods/ ways of working) we individually really care about or believe in, while the half-lived, pretentious ones crumble away in the struggle with the other person and the exchange.

Experience? Erosion? Meltdown? Sensitivity. Friendship. Big fun.

How would you describe what your doing in your art... and what I'm doing in my art?

Wow. I guess from the time I met you and you did the TRUDI show I thought of you as an expert and me as a novice, of which I still feel, but I'm willing to argue more now. Before I just wanted to say "yes" to everything. But I also thought that you, or atleast your practice was so cold and hard, but in my current frame of reference you and your practice (which I can no longer separate) are warm and giving and full of wonder-lust. While my artmaking looks warmer but is about negating, trying and refusing, and our collaboration has made this more evident. Instead of trying to change that in my solo work I am consciously trying to be more closed in it and more open in MCAW (my unofficial nickname for the collaboration). It's work, but it's a good distinction for me.

Maybe this can all become one bigger answer.

Can we learn something from each other - can artists learn from each other (nowadays) in general ? - and what kind of things ?

The big questions. We can definitely steal from each other. Life is very competitive and somewhere on the other side of the coin is pushing away, criticality as a defining tactic. I remember as a small child watching a presentation by a former drug addict who said something to the effect of "You won't learn from an example, you'll learn from a disaster" to the effect that he was a disaster and we shouldn't want to repeat his mistakes. I think both you and I have taken things from each other, maybe learned, but probably not what we have wanted impart on the other. As artists we take a privileged position where we assume that we need to be heard and it takes a lot to listen, and I have listened to you: I learned to make gradients with paint rollers.

Learning to say: The big questions. We can definitely. Life is very competitive. Other Side of the coin. I remember as a small child. Wow. It's work, but.... I was able to surrender to the act of painting. (I think I agreed sooner than that!) I have always enjoyed the notion of maybe I care about art. Wow.

We have thrown the word "romance" and "romantic" around during our conversations can you talk about its relevance to you?

We're not making romantic conceptualism.

But we are conceptually romantic, we have left the studio to make the beautiful meal for our respective beauties of the night.

At the same time we're both aware that we cannot control our creative output, neither by language nor by painterly means. Rather we embrace the mystical and emotional driven irregularities that are part of an artistic practice, which is a romantic sensibility.

The romance builds around it, and about what's going on between the works and us. There's just as much contempt and denial going on at the same time.

Is that why you wanna paint everything? Why do you wanna paint all that stuff? Would you keep doing it if nobody was interested?

Yes. Images are images. Painting them gives me a hierarchy. Separates the wheat from the chaff. I would probably repaint over them more though if no one was looking.

And can you explain the idea of being a "weekend typographer"?

WEekend typographer - tropical dandy - part time punk - technical Ecstasy - western exterminator - circle jerk - amateur archaeologists

The typographer is addicted to detail it's very much about spacing as well as flowing in the currents of the time nobody should be able to read that

Except from the fact that you're German and I am American, what connects us with DAF ? (Deutsch Amerikanische Freundschaft)

Well we are both Mark E Smith and we both pull the words out of the air.

I don't know what the work is about. Except work. It's maybe related to our education. Post war German works ethics are legendary, from what I understand. Americans think of Germans as hard working fellas and like them for that. They like to be hard working fellas themselves. It is what makes the American Dream come true. Find inspiration in leisure, excess, dreams, inertia, hangover, moodiness, procrastination, false friends, fakes, inconsistence, opportunism.

There have been no agreements with signatures, no secret handshakes, no matching outfits.

while it might appear, that like everyone else and their dog, we're dissecting painting - we're coming back to ignored leads in the investigation of the artist.

This role: No careers, we are a tortured artist, we demand subversion, we have to get up pretty early in the morning to fool the other.

We have no mark.

Well we are both Mark E Smith…, do you remember what he represented in that conversation?

Techno/Fassbinder's 3rd Generation/ I drink early you drink late.

Drinking isn't drinking. Would you come with a bottle of Vodka to repair the bathroom? What is drinking in the afternoon for? Does it cheer you up? I don't like the brain feeling drowsy at daytime, confused in the afternoon, being tired before the evening starts. I can't work when when I'm drinking except at night. I don't care about being social in the studio when there are people around.

I want to drink alone.

Do you drink alone?

Except for the fact that neither of us are British, what connects us with Crass? Did you know that krass means extreme in German.

Things have always been pretty krass all the time.

Is our collaboration krass?

In a business sense.

Is our collaboration the child of political post war relations?

What isn't?

Do you still call the US the New World?

We still make new problems.

What's our artist statement?

maybe this could be it:
"We are deeply immersed in this situation and we are the water and the algae that constitute it. We do not emerge from it directly by denying it, but by breaking down the various components of our element, following the stress lines." (Bataille)

Is all work stemming from collage? or college? or colleague?

Where do you stand with your art, colleague?
it says on the painting of Joerg Immendorf
Where do you position yourself with your art, dear colleague?

Is it about people having similar political views? Is personal experience of social politics at the bottom of our painterly decisions? Can we overcome our traumata together:

I just don't know if there are really any more artists in the way as there were 100 years ago. But maybe those where different people within their society as the artists 500 years ago. It's all pop culture industry now. Maybe the Impressionists were pioneering that move. Are you good at playing a pop star?

Collage is the spiffiest form of painting. It is the meanest medium and becomes increasingly so. Making good collages bad is so bad like making bad ones good ones bad. It's a natural talent type thing. Can you collage this text and make it more funny?

No way, this is like one of the paintings, I won't touch it to be funny. ANd the meanest medium is work. Hard work. Transcendent hard work.

Oh really, what about post-conceptual photography about sculpture?

Galerie Mezzanin, Wien, 2012

Das ist für mich nun keine neue Situation, Das ist für mich nun keine neue Situation,
schon mehrmals stand ich zu Ausstellungseröffnungen und sehr gerne würde ich aus Gewohnheit wieder sagen – des Berliner Künstlers – Alexander Wolff zur Eröffnungsrede, und schon wäre man bei einem Thema des Künstlers, jenem der Wiederholung. Aha also, ich bin jetzt schon wieder der sprechende Ausstellungs-Dummy, wie eine mit zahlreichen Sensoren ausgestattete Puppe in Form eines Menschen und in der Vernissagenforschung bei Ausstellungseröffnungen in Verwendung, und übersetze meine noch frischen Eindrücke in einleitende Worte zur Ausstellung. Sie können es mir glauben, viel lieber würde ich sie jetzt bereits alleine lassen mit dieser Ausstellung, auch aufgrund folgendes Verdachtes: „ Hier bedeckt die Sprache Orte und Situationen eher, als sie zu entdecken. Hier verschließt die Sprache Türen zu utillitaristischen Interpretationen und Erklärungen, anstatt sie zu öffnen. Die Sprache von Künstlern und Kritikern, auf die sich dieser Artikel bezieht, wird zu paradigmatischen Reflexionen in einem spiegelverkehrten Babel, das entsprechend Pascals Bemerkung, Die Natur ist eine unendliche Sphäre, deren Mittelpunkt überall und deren Umfang nirgendwo ist,, aufgebaut ist. Der gesamte Artikel kann als Variation dieser oft falsch verwendeten Bemerkung verstanden werden, oder als ein monströses Museum, das aus facettenreichen Oberflächen konstruiert ist, die sich nicht auf ein einziges, sondern auf viele Subjekte innerhalb eines Wortgebäudes beziehen – ein Ziegelstein = ein Wort, ein Satz = ein Raum, ein Absatz = ein Stockwerk, usw. Oder die Sprache wird zu einem unendlichen Museum, dessen Mittelpunkt überall ist und dessen Grenzen nirgendwo sind." Also wenn ich diesen allgemeinen Zeilen eines schreibenden Bildhauers weiter folgen darf, könnte das meine nur scheinbar ungünstige Position unterstreichen, jetzt heute hier in der Ausstellung über die Ausstellung zu sprechen, sollte ich nicht eher am Adams Blvd. in L.A über diese Mezzaninausstellung sprechen, Alex? Bin sicher nicht nur vom Künstler platziertes Ausstellungsdummy, bin auch sozusagen

Komplementärkontrast, geradeso als würde ich Dachlawinen-Warnstangen halten müssen, dabei die Dachlawinengefahrenzone nicht verlassen dürfen – und nicht vor oder neben mir, sondern über mir : Gewähltes, Kooperationen, Gemaltes, Abstrahiertes, Ansätze, Fertiges, Wesentliches, Unterscheidungen, Entscheidungen, Korrekturen, Analysen und Synthesen, Kombinationen, Erforschtes, bis heute 18 Uhr in Zusammenhang gebrachtes nass und schwer im Galerieinneren drückend lauern und ich müsste dabei gleichzeitig hier in der Ausstellung über die Ausstellung sprechen. Aber so fühlt es sich nicht an, es ist wohl offener angelegt: The Wallpaintingreader-Wallpainting-Reader-Wall im Eingangsbereich zeugt etwa davon. The Wallpaintingreader-Wallpainting-Reader-Wall! In einer Einleitung einer anderen Ausstellungseröffnungsrede, fand ich die mögliche Publikumserwartung eines Vortrages eines Liedes, das ich zur Einleitung einer anderen Ausstellungseröffnung gesungen hatte, mit folgendem Einschub – mein gott jetzt singt er gleich – gut abgeschmettert, heute wiederum wäre ein Vortrag eines Liedes durchaus angemessen, anhand mancher in die Ausstellung hineinragender Themen, sie werden sie gleich erkennen. Ein weiterer Verdacht wäre, das ich deshalb als Eröffnungsredner bei den Vernissagen von Alexander Wolff fast abonniert bin, wegen meiner Neigung Sätze nicht ganz zu Ende zu sprechen und dadurch Momente weiträumiger Interpretationen, jenen der präzisen Vorwegnahme überwiegen und dabei dennoch kaum zeitlich überziehe: In diesem Sinne: Die Tage der evangelischen Chormusik 1982 kommen erst, wie überhaupt erst alles kommen wird, die Reise wird lang und seltsam und an deren Ende wartet hoffentlich wieder der Ausgangspunkt der Reise, ein bisschen war die Rede auch wie Versuche mit der Kreideschlagschnur Schlieren zu ziehen, ja ich mag die Wolffsche Doppelbödigkeit aus Unrast und Kalkül noch wieder schon einmal sehr, nehmen sie diese Rede bitte wie ein verpacktes Spikemagazin oder eine nicht zurückgegebene Vhs-Kassette aus dem Alphaville oder als Happy Birthday Arts birthday, der heute eine Million neunundvierzigste bereits!

Christian Egger

Kestnergesellschaft Hannover, 2012
Katalogtext Made in Germany

Alexander Wolff beschäftigt sich mit Erscheinungsformen, Möglichkeiten und Grenzen von Malerei als Tafelbild, Wandbild, Fotografie, Bild im Raum, Raumbild. Dabei beschränkt Wolff sein Tun weder auf den begrenzten Bildraum der Leinwand noch auf Öl- oder Acrylfarbe. Auch Textilfarbe, Schmutz, Staub, verschiedenfarbige, aneinander gefügte Stoffe und Licht zählen zu den Materialien, aus denen heraus seine Bilder entstehen. Materialkombinationen und Formatvariationen erzeugen und bearbeiten Rahmen, Ränder und Übergänge, in deren Zwischenräumen immer wieder die Frage aufscheint, was Malerei noch alles sein kann, welche Voraussetzungen und Vorstellungen über den Status von Bildern mit ihr verknüpft sind. Wodurch nehmen wir ein Bild als Bild wahr? Welche Räume eröffnet das Bild im Raum und wie verändert sich der Raum durch das Bild? Wie spielen Bild und Raum zusammen und wo treten sie gegeneinander an? Was ist ein Bild?

Ein Bild ist unter anderem das, was sich selbst als solches thematisiert. Diejenigen von Wolff tun dies etwa, indem sie Grenzen von Bild und Umraum verwischen und den Betrachter als Bildelement integrieren. Bei einem Wandbild, das Alexander Wolff 2011 in dem Kunstraum SVIT in Prag malte wird als Material gelistet: Glas, Luftpolsterfolie, Klappstühle, Acryl, Kopien, Schreibtischlampen. Klappstühle sind sowohl Element des Bildes auf der Wand, als auch zwei Bestandteile im Raum, so positioniert und angestrahlt, dass ihre Schatten auf der Wand verschmelzen. Setzen sich nun Besucher auf die Stühle, überlappen sich auch ihre Schatten, werden Teil des Bildes. Das bedeutet auch, dass das Bild niemals fertig ist, sondern immer im Prozess des Werdens, unabschließbar und gleichzeitig in jedem Moment des Betrachtens anders und temporär vollendet.

Das Addieren von Materialien, Licht und Körpern zu einer Komposition ist ein Verfahren, dessen sich Wolff bedient, ein anderes ist das Subtrahieren, Auslöschen, Ablösen. Wie etwa von Raufasertapete für das Wandbild, das 2006 bei Circuit in Lausanne entstand. Eine teils scharf umrissene, teils ausgefranste Rautenstruktur wird hergestellt, welche streckenweise die Illusion von Raumtiefe erzeugt. Das Bild bewegt sich hier am Rande des Verschwindens im Umraum und erscheint doch einzig

auf der Basis der Beschaffenheit eben dieses Raumes. Er fügt Leerzeichen ein, die die Wand lesbar machen. Weder Raum noch Bild sind gegeben oder selbstverständlich sondern Ergebnis von strukturierenden Aktionen, Entdeckungen, Experimenten. Alexander Wolffs Raum-Bilder falten sich in die Wand hinein und aus ihr heraus. Seine Leinwände – als mobile Bildwerke, deren Kontext wechselt – sperren sich nicht minder gegen die Reduzierung auf eine Ebene und Abgeschlossenheit. Hier wird die Fragmentierung, die sich bei den Wandbildern auf den Umraum und die Situation bezieht, im Bildraum selbst vorgenommen. Zum Beispiel, wie in einer Reihe von Arbeiten aus dem Jahr 2011, indem Wolff Stoffe färbt und miteinander vernäht, so dass Überlappungen und Nähte entstehen. Aus der Fernsicht erscheinen die Bilder als geometrische Strukturen, zusammengesetzt aus homogenen, zum Teil an den Rändern ausfransenden Farbflächen. Die Nahsicht offenbart Nähte und die Zusammensetzung der Flächen aus unterschiedlich farbigen Pigmenten. Die Komposition wird erkennbar als zum Teil aleatorisch, den Zufall und die Eigengegensetzlichkeit des Materials in die Struktur, den Bildraum-Container, integrierend. Alexander Wolff ist damit nicht nur Maler, sondern auch Maler-Betrachter und Arrangeur, dessen Bilder nicht zuletzt die Bedingungen ihrer Bildhaftigkeit zum Gegenstand machen. Diese Bedingungen werden nicht nur beobachtbar durch die sichtbaren Elemente, sondern ebenso durch die Lücken und Nahtstellen innerhalb der Bilder; zwischen einem Bild, das abstrakt wirkt und dem konkreten Material, das dieses Bild hervorbringt; zwischen Formen des Bildes und Formen des Raumes. Eine weitere Nahtstelle ist diejenige zwischen dem manuell gefertigten und dem fotografisch oder filmisch erzeugten Bild. Durch die Integration von Fotografien oder Videos in diese Bildräume wird das Verhältnis von abstrakten und repräsentierenden Elementen ebenso thematisch wie der Aspekt von Bewegung, Statik und Licht. Kasimir Malewitsch sprach im Zusammenhang mit seinem Schwarzen Quadrat auf weißem Grund (1913) von der Befreiung der Malerei vom „Gewicht der Dinge". Alexander Wolff scheint eher auf diesem Gewicht zu insistieren als notwendige Bedingung, überhaupt von Malerei sprechen zu können.

Kathrin Meyer

Overbeck-Gesellschaft, Kunstverein Lübeck, 2012

Text zur Ausstellung
von Kathrin Meyer, Christian Egger, Alexander Wolff

painting as a recycling machine,
toilet flush for the brain

wie will man die Geschichte der Objekte erzählen

eine Art zu schauen
mehrere Arten zu schauen ausstellen
Institutionen erschaffen Perspektiven

die Institutionen heißen: Kirche Museum Kunstverein
Kunstgeschichte (Ethnologie)
Stadt
Atelier
My idea of you is in the studio with me. Is it not the same for you?
It's like a third component in the relationship that normally is just
me and the work. I don't care about being social in the studio when
there are people around.

the objects need a story or history to give them value

in wieweit ist Ethnologie von Kunstbetrachtung different
ist uns unsere eigene Kultur genauso fremd
oder warum muss man das Fremde immer weniger verstehen als das,
was man als das eigene glaubt
diese ganze Misere in den kolonialen Forschungsreisen bestand
doch in der eurozentristischen Sicht, aus der man alles in das
eigene Denken, aus dem eigenen Denken heraus kommentieren und
kategorisieren muss.

Doch wer mit ihr aufgewachsen ist, wird ihren Umgang mit der
Realität, in der sich auch die eigene Erfahrung spiegelt, nicht missen
wollen, auch sie macht süchtig wie so vieles Konjugierbare - oder
gehe ich da zu weit, ist der Strich, der Schatten, die Kontur nicht
mehr verbindlich, verbindet die Handschrift nicht mehr, hat die Seele
keinen Abdruck?

Thomas Mann: "In Ansehung des allgemeinen Notstandes aber, von
dem eine Fülle teilweise ergreifender Bittgesuche mir sogleich nah

Bekanntwerden der Stockholmer Entscheidung ein nur zu lebendiges BIld gab, hat tatsächlich dieser Lübecker Plan, wenn es Ihnen auch hart klingen mag, etwas Luxuriöses."

Es ist so, als ob wir in dieser "neutralen" Umgebung die einzelnen Bilder erst überhaupt erkennen. Das gleichmäßige Licht, die ruhigen, indifferenten Wände, die historische Unbelastetheit des Ortes wirkt ausgleichend. Die Bildwerke sind aber auch auf sich gestellt, und es ist erstaunlich, sie in dieser Selbstbehauptung sich bewähren zu sehen.

Wem gegenüber bewähren sie sich? Mir? Dir? Euch? Ihnen? Malerei als Recyclingmaschine. Recycling von Kulturversatzstücken, Illusionen, Zuschreibungen, Assoziationen, Fremdem, Vertrautem, Farbe, Objekten, Mitgebrachtem (Gegebenem) und Genommenem. Und immer wird gegeben. Recycling in der Abfallwirtschaft hat das Ziel, ein neues Produkt zu erzeugen. Wo entsteht das Produkt der Recyclingmaschine? Auf der Wand? Im Auge und Geist des Betrachters? Im Blicken, im Treffen von Material und Netzhaut? In Worten, also auf der Zunge? Auf Papier? Im Körper?

TJ Clark ging ein Jahr lang immer wieder zu demselben Bild, um es anzuschauen, jeden Tag. Was sieht man, wenn man ein Jahr lang immer wieder ein Bild besucht? Worauf ich hinauswill: Wir hatten ein Wandgemälde von Alexander Wolff bei uns in der kestnergesellschaft, für drei Monate, und nicht nur hat sich das Bild selbst immer wieder verändert, weil zwei Diaprojektoren wechselnde Dias projizierten, sondern ich habe mich in den drei Monaten verändert und ich frage mich, ob mich nicht auch die Bilder verändert haben. Ich meine, was sieht man denn da? Das Bild, sich selbst? Und warum schaut man überhaupt darauf? Beyond Zweckrationalität lies another kind of being. Bis zuletzt haben wir befürchtet, dass jemand das Tesa-Krepp aus dem Wandbild abzieht. Ist aber nicht passiert.

"Do we not, through an odd reversal, as we stand in the gallery space, end up inside the picture [...]?"[1] How do we feel as the picture? How does it feel to be or to be called abstract, figurative, colorful, black-and-white?, square, round? How do we, as the picture, relate to the Ibeji figures? How do we communicate? In the <u>eye of the beholder </u>who is inside the picture we become one, and

1 Brian O'Doherty, *Inside the White Cube. The Ideology of the Gallery Space*. Expanded Edition. Berkeley / Los Angeles: University of California Press 1999, S. 39. (1976 erstmals erschienen)

yet never are, as one plus one is two, not one. I think one plus one is even more, like, three, four, five....

Paintings in disguise. Figueroa it out yourselves. The connection between what we painted and what we talked is back and forth. I'm trying to express this as truthful as I can think. Sometimes I wanna take the affirmative sound out of this conversation and make it sound more private, or get closer to poetry, being at home in what language can do. But it feels rather akward anyway.

I know I had used the metaphor that our collaboration was like (or I wanted it to be like) a business, in the sense that we were the laborers applying paint, but then we became the board of directors and made the best decisions for the work separate from the painterly passion.

Learning to say: The big questions. We can definitely. Life is very competitive. Other side of the coin. I remember as a small child. Wow. It's work, but.... I was able to surrender to the act of painting. (I think I agreed sooner than that!) I have always enjoyed the notion of maybe I care about art. Wow.

But we are conceptually romantic, we have left the studio to make the beautiful meal for our respective beauties of the night.

zum Richtfest der Overbeck-Gesellschaft Juli 1930 von anonym
Gegründet tief in fester Erden,
So steht nun unser Bauwerk hier.
Mag es ein würdig Denkmal werden,
Der Kunst ein Heim, der Stadt zur Zier.

Die Overbeck-Gesellschaft plante
Dies Werk, trotz schwerer, harter Zeit
Und williger Opfermut der bahnte
Den Weg mit Gebefreundlichkeit.
...
Dem Architekten, der den Riss
Entworfen, seiner Kunst gewiss.
Dem Meister, welcher diesen Bau
Geleitet und bewacht genau.

Hoch. Hoch. Hoch.

Über den Architekt Wilhelm Bräck
"Es kommt doch gar nicht darauf an, einen beliebegen zufälligen Gedanken kunstvoll auszudrücken, sondern es sollen die besonderen Bedürfnisse einer Person, einer Familie mit der Seele erfasst und mit alle Wohlwollen dargestellt werden."
Er pflegte dann gelegentlich zu sagen, die Idee sei ihm träumlings gekommen.
Rastlosigkeit und Besinnlichkeit vereinigten sich in diesem seltenen Menschen.
"Jedes Werk hat eine bewegliche Verbindung mit den naturlichen Kräften seiner Einheiten, die es gilt zu erfassen und in anpassendem Wechsel auf die Begriffe und Empfindungen einer Zeitwandlung einzustellen. In jedem Gebilde ist ein Herzenspendel tief versteckt, dass nur des Anstoßes bedarf.
So muss also das Haus, die Wohnung so etwas wie eine Art Seele haben."

Wie die Ibeji-Figuren.

"Einfach ein Bild an die Wand hängen und sagen, das sei Kunst, ist scheußlich. Das ganze Geflecht ist wichtig! [...] Nur "essen mit Augen" wie der Japaner sagt, also die Bilder selbst ansehen ist uninteressant! Wenn du sagst KUNST, dann gehört alles dazu, was darunter fallen könnte. Das heißt von einer Galerie auch der Fußboden, die Architektur, der Anstrich. Das ist alles genauso wichtig wie das Bild an der Wand selbst."[2]

Was mich an Malerei interessiert, ist tatsächlich weniger das Bild selbst als das Bild und seine Verbindungen. Das Bild ist immer eingebunden in andere Bilder, im Entstehen wie im Erinnern oder im aktuellen Betrachten.

"Man vergeudet seine Zeit – oder tut jedenfalls so. Man gibt seinen Impulsen nach und schweift ab. Man biegt plötzlich ab. Man unterscheidet nichts mehr, sondern setzt sich den Unterschieden ganz unmittelbar aus. [...] Tatsächlich geht es darum, an sich selbst einen Wechsel der Sichtweise zu erleben: seine Stellung gegenüber dem Subjekt zu wechseln, um die Definition seines Objekts wechseln zu können."[3]

2 Jutta Koether; Ein Interview mit Martin Kippenberger. In: *Texte zur Kunst*, Sommer 1991, 1. Jahrgang, Nr. 3. Köln 1991, S. 90–93.
3 Georges Didi-Huberman, *Das Nachleben der Bilder. Kunstgeschichte und Phantomzeit nach Aby Warburg*, Frankfurt/Main: Suhrkamp 2010, S. 48, f. (*L'image survivante. Histoire de l'art et temps de fantômes*

"Inwiefern war dieses Objekt in der Lage, einen Wechsel des Objekts 'Kunst' herbeizuführen, das die Kunstgeschichte als Fachgebiet traditionell ins Auge faßt? Insofern es sich nicht eigentlich um ein Objekt handelte, sondern um einen Komplex – einen Haufen, ein Konglomerat oder ein Rhizom – aus Beziehungen. Das ist ohne Zweifel der Hauptgrund, weshalb Warburg sich sein Leben lang so leidenschaftlich für die Berücksichtigung anthropologischer Fragen einsetzte. Die Verankerung der Bilder und Kunstwerke im Feld der anthropologischen Fragen war ein erster Weg, einen Wechsel in der Kunstgeschichte herbeizuführen, aber auch, sie auf ihre eigenen 'Grundprobleme' zu verpflichten. Als Historiker lehnte Warburg es – wie Burckhardt vor ihm – ab, diese Probleme auf der Begründungsebene aufzuwerfen, wie Kant oder Hegel es getan hätten. Die 'Grundprobleme' aufwerfen hieß nicht, das allgemeine Gesetz oder das Wesen einer menschlichen Fähigkeit (der Schaffung von Bildern) oder eines Wissensgebiets (der Geschichte der bildenden Kunst) zu ermitteln. Es hieß, den Untersuchungsbereich auf weitere einschlägige Einzelfälle auszudehnen und das Feld der betrachteten Phänomene zu erweitern bei einem Fachgebiet, das bis dahin auf seine Objekte fixiert war wie ein Schuhfetischist auf seine Schuhe – und dabei die Beziehungen ignorierte, die seine Objekte herstellten oder durch die sie zustande kamen."[4]

Beziehungen. Wand. Architektur. Familie. Kunst. Expeditionen. Reisen. Statuen. Kult. Statuen, welche die Seele eines toten Zwillingskindes enthalten. Die Mütter trugen diese Figuren ganz nah bei sich, sie wuschen und pflegten sie und einmal im Jahr tanzten sie, um sie zu ehren. Gesten, die auf Material einwirken und es umwandeln, beleben, zum Leben erwecken.

Wer malt denn am Ende wen? Der Maler malt die Malerei malt die Malerei malt die Malerei die Malerei malt den Maler der die Malerei malt malend die Malerei die malt die Malerei die malt die Malerei die malt die Malerei die die Malerei malt den Maler der die Malerei malend malt.

Nochmal zurück zu Kippenberger, der auch gesagt hat, dass das Bild Teil eines Geflechts sei! Wir sind das Geflecht, ihr seid das Geflecht, meine Stimme, dieser Text, diese Texte, die Bilder, die Objekte, das Haus, die Treppe, der Boden, eure Vorstellungen, die Farben, die Nähte, die Geschichte, das Sichtbare und Unsichtbare, das Rohe und das Gekochte, meine Rollen, eure Rollen, Zuschreibungen,

selon Aby Warburg, Paris 2002)
4 Ebd., S. 50, f.

Abschreibungen, Anschreibungen, Schreibungen.

Vierter Punkt des Manifests nach der Abstraktion: "Das ist wahr: Abstraktion kommt zum Erscheinen, wenn die dominierenden Darstellungskriterien nicht mehr in der Lage sind, die Grenzgebiete der Wahrnehmung abzudecken. Abstraktion ist die formale Erlösung des individuellen Deliriums zur Markierung eines unendlichen Gemeinwesens."[5]

Kurt Schwitters schrieb aus dem Exil: "Ich bin selbst nur ein Aufnahmeapparat." Seine Collagen, seine Bilder, sein Merzbau sind Teile von Eingebungen und Ideen, die einen Niederschlag im Material gefunden haben. Schwitters baute seinen Merzbau aus Begegnungen mit der Stadt, schuf die Collagen aus Schichten von Gefundenem und Gesammelten. Der Merzbau war ein Innenraum, ein seelischer oder mentaler Raum, in den Schwitters ab und an Menschen einlud und in dem er auch Ausstellungen veranstaltete. Vor allem aber lebte der Merzbau, war Ausdruck, Niederschlag und Katalysator von Stimmungen, Ungreifbarem.

Sammeln, Zueinander stellen, vernähen. Alexander Wolffs Raum-Bilder falten sich in die Wand hinein und aus ihr heraus. Die Nahsicht offenbart Nähte. Die Bedingungen von Bildhaftigkeit werden nicht nur beobachtbar durch die sichtbaren Elemente, sondern ebenso durch die Lücken und Nahtstellen innerhalb der Bilder; zwischen einem Bild, das abstrakt wirkt und dem konkreten Material, das dieses Bild hervorbringt; zwischen Formen des Bildes und Formen des Raumes. Zwischen Betrachter und Figur, zwischen Wand und Boden, zwischen Geräusch und Stille.

28.9., zwischen 0 und 3 Uhr
Ich versuche von Hannover aus anhand von Bildern und Beschreibungen sowie dem Zusammenbringen des Erinnerten, Gelesenen und Gesehenen eine Vorstellung von Alexanders Ausstellung in der Overbeck-Gesellschaft zu entwickeln. Es ist Freitag nacht, die Ausstellung dort steht schon fast, nur das Churches Video läuft noch nicht (so der Bericht). In den Ausstellungsräumen der Overbeck-Gesellschaft kombiniert Alexander Wolff Objekte verschiedener Herkunft und aus verschiedenen Zeiten. Ein Tangka ist auch dabei, ich habe vorher noch nie davon gehört. Es ist ein transportables Meditationsbild, das im Buddhismus zum Einsatz kommt. Ich lese ein wenig darüber und erfahre, dass die Anlage

[5] Yves Mettler / Erin Olivia Weber / Alexander Wolff: "Manifest nach der Abstraktion", in: Dies., *Eu R Us*, Westphalie: Wien 2012.

eines Tangkas strengen Regeln folgt, das Wissen von Meistern an Schüler weitergegeben wird. Die Motive sind nicht festgelegt, aber einige wiederholen sich, wie etwa das Lebensrad. Was mich mehr fasziniert: Das Bild ist ein Gebrauchsbild, es kann mitgenommen und gemeinsam betrachtet werden. Dabei geht es weniger um formale Fragen. Das Bild ist ein Vehikel, um an andere mentale Orte zu gelangen. Rechts und links neben dem Tangka hängen Gemälde von Alexander Wolff. Sehr reduziert, das linke besteht aus blauen und weißen Farbflächen, das rechte aus einer blauen Fläche. Ich erinnere mich, Alexander schrieb per Email: "die ganz reduzierten Bilder sind eine 7 teilige Serie von 2003 namens 'postcard paintings' und nach Postkarten-Reproduktionen von Werken von Judd, Newman, Stella , Y KLein und anderen gemalt. Wo es um den weißen Rand um das Originalformat zur Anpassung ans Postkartenformat geht."

Gemälde in Postkarte in Gemälde. Ich denke an die Postkarten in den Museumsshops. Einmal habe ich eine von Barnett Newman gekauft: Who's afraid of Red, Yellow and Blue?. Das Bild ist im Original knapp 2,44 m hoch und 5,44 cm breit. Ich bin 1,66 groß. Ich habe das Bild einmal gesehen, es war gut gehängt, nämlich so, dass ich dem Bild ganz ausgesetzt war. Ich konnte nicht weit zurückgehen, war eigentlich zu nah dran. Newman wollte wohl auch, dass es so gehängt wird, denn es ging ihm um die Wirkung der Farbe und die Intensität der Farberfahrung. Man sollte dem Bild nicht entrinnen können. Er hatte sich geärgert über Mondrian, dessen Verwendung der Grundfarben mit Ideen begründet war. Mondrian sah in diesen Farben so etwas wie Grundelemente, auf die sich jede Erscheinung zurückführen lässt. Die Bilder sind abstrakt in dem Sinne, dass sie eigentlich immer auf die äußere, sichtbare Realität bezogen sind. Sie sind Abstraktionen von Dingen und Personen, die in der Welt eine ganz konkrete physische Präsenz haben. Theo van Doesburg schrieb, dass sie in der Wirklichkeit konkret sind, eine Kuh oder ein Baum, eine Frau in der Malerei aber viel abstrakter seien als eine Linie, Farbe.[6] Barnett Newman wollte die Farbe von den Ideen befreien und ihre Expressivität in den Vordergrund bringen, wie etwa in "Who's Afraid of Red, Yellow and Blue?". Der Titel des Bildes klingt tatsächlich wie "Wer hat Angst vorm bösen Wolf?" Ironisch, ein bisschen bissig, immerhin geht es um Farben. Immerhin! Es geht um die Wahrnehmung der Farbe als solche, um ihre Wirkungen.

6 Vgl. Max Imdahl, "'Is It a Flag, Or Is It a Painting?' Über mögliche Konsequenzen der konkreten Kunst", in: Ders., *Gesammelte Schriften*, Bd. 1: *Zur Kunst der Moderne*. Frankfurt am Main 1996, S. 131ff.

Auf der Postkarte verliert sich diese Wirkung vollständig. Man hat dann ein Stück Karton mit einigen Farben und einen Gegenstand, der einen an das Bild erinnert und an die Erfahrung, es gesehen zu haben. Alexander Wolffs Postcard Paintings gehen von diesem Stück aus, von diesem Stück Karton, das man mitnehmen und verschicken kann, an die Wand hängt und das immer auf etwas anderes verweist und dabei doch auch selbst eine Wirkung entfaltet. Die Wirkung ist letztlich unsichtbar. Gernot Böhme schreibt von der Atmosphäre als dem sinnlichen Eindruck, den ein Objekt, eine Umgebung, ein Raum erzeugt. "Man redet von der lieblichen Atmosphäre eines Tales oder der anheimelnden Atmosphaere eines Gartens. [...] Von einem Menschen kann man sagen, dass er eine achtunggebietende Atmosphäre ausstrahlt, von einem Mann oder einer Frau, dass dsie eine erotische Atmosphäre umgibt. Auch hier bezeichnet Atmosphäre etwas in gewissem Sinne Unbestimmtes, Diffuses, aber gerade nicht unbestimmt in bezug auf das, was es ist, seinen Charakter. Im Gegenteil verfügen wir offenbar über ein reiches Vokabular, um Atmosphären zu charakterisieren, nämlich als heiter, melancholisch, bedrückend, erhebend, achtunggebietend, einladend, erotisch usw. Unbestimmt sind Atmosphären vor allem in bezug auf ihren ontologischen Status. Man weiß nicht so recht, soll man sie den Objekten oder Umgebungen, von denen sie ausgehen, zuschreiben oder den Subjekten, die sie erfahren. Man weiß auch nicht so recht, wo sie sind. Sie scheinen gewissermaßen nebelhaft den Raum mit einem Gefühlston zu erfüllen."[7]

Die Ausstellung in der Overbeck-Gesellschaft geht dann weiter mit Arbeiten, die 2011 in Zusammenarbeit mit Matt Chambers entstanden sind. Ich folge dem Link, den Alexander geschickt hat und lese über diese Zusammenarbeit. Matt Chambers schreibt: „What started out as Alexander wanting to make some figurative paintings and me wanting to let some chaos into the studio has blossomed into a group of dense paintings, works on paper, sculptures, and a video. In our first meetings we just talked, an activity that we both noticed was largely absent in our respective circles."
Jetzt kommt es: „We both had plenty of ideas but neither of us liked anything the other suggested, and so it was that disagreement got us to begin working together. More talking ensued, also some drinking, yelling, some more work, and then some more talking. The slow process akin to erosion or senate-floor debates created pieces without precedent. Differences of opinion were constant, and each of us

[7] Gernot Böhme, *Atmosphären*, Frankfurt/Main: Suhrkamp 1995, S. 21, f.

fought for and honed our objectives with the understanding that no argument could be used twice. There is no common ground between us in regards to ‚what is cool' or ‚what is not cool.' And in contrast to the current fashion in abstract painting and in our own solo practices, we used no system that would allow our work to repeat itself."[8] Die Zusammenarbeit beruhte nicht auf Übereinstimmung, sondern darin, dass man sich in der konstanten Nicht-Übereinstimmung verstand und begriff, dass beide in der Zusammenarbeit wahrscheinlich an Punkte kommen würden, die sonst nicht erreichbar wären. Ich denke über das Fremde nach und das Zusammentreffen und finde so langsam so etwas wie Konturen, Ecken, Kanten, Wiederholungen, die sich verdichten. Mir fällt dieser Derrida-Text ein: Signatur Ereignis Kontext.[9] Darin schreibt er über die Wiederholbarkeit, Iterabilität, als Voraussetzung für die Entwicklung von Sinn. Das Zeichen kann aus einem (konkreten oder semantischen) Kontext herausgelöst und in einen anderen „eingepflanzt" werden ohne dass es aufhört, als Zeichen zu funktionieren. Differenz und Iterabilität sind konstitutiv für das Zeichen. Gleichzeitig bewirken sie, dass das Zeichen allein für sich keine Sinneinheit bilden kann, sondern immer nur in Zeichenverkettungen verstanden wird. Der Sinn bleibt nie genau gleich, jede Wiederholung reichert das Wiederholte an, erweitert es, faerbt es.

Was sich hier, in dieser Betrachtung der Ausstellung die ich noch nicht gesehen habe, bis jetzt, wiederholt: Anwesenheit und Abwesenheit. Das Zusammentreffen mit etwas Fremden, etwas Unvertrautem. Und nun: Religion. Denn einen Raum weiter finden wir ein Video, das verschiedene Kirchen in Los Angeles zeigt.

„There is no good or bad. There is boring and interesting; and if you're interested in cats, I think you will find this work to be interesting."[10]

In den USA gibt es eine Vielzahl von Glaubensgemeinschaften, Kirchen, Sekten. Die Kirchengebäude sind neu, exotisch aus unserer Sicht, oft kitschig und überladen – kein Vergleich mit unseren gotischen Kathedralen oder schlichten protestantischen Dorfkirchen. Der Blick Alexander Wolffs konzentriert sich mehr auf die Formen, die Dinge, die Einrichtung, das Licht. Bild-Erforschung. Die Formen

8 http://www.steveturnercontemporary.com/artists/chamberswolff/index.html, Zuagriff am 28.09.2012
9 Jacques Derrida: „Signatur Ereignis Kontext", in: Randgänge der Philosophie, Wien: Passagen 1998, 291-314.
10 http://www.steveturnercontemporary.com/artists/chamberswolff/index.html, Zugriff am 28.09.2012

und Farben verweisen auf etwas nicht Greifbares, evozieren die Präsenz Gottes in den Gläubigen, möglicherweise.

Sehen und Affiziert-Werden vom Gesehenen. Meditieren, analysieren, erfahren, erfinden, suchen, wieder verwenden, Verkettungen herstellen und wieder lösen, Sachen zusammen nähen, sich in eine Tradition stellen und sich weit weg begeben von ihr, auf neue Wege, alte Wege, eigene und fremde Wege.

Ich freue mich darauf, das Wandbild zu sehen. Ich habe einmal gesehen, wie Alexander Wolff an so einem Wandbild arbeitet und mir scheint, dass die Musik dabei total wichtig war. Vielleicht weniger für Alexander, ich habe ihn bisher noch nicht gefragt, ob und wie die Musik da mit rein spielt, ihn vielleicht beeinflusst oder so. Aber für mich spielt sie eine große Rolle, weil sie so etwas wie einen Soundtrack geliefert hat für das fertige Bild. Und wenn ich jetzt, wenn das Bild schon gar nicht mehr existiert, längst abgebaut wurde und nur noch auf Fotos herumgeistert, zum Beispiel das Stück E2-E4 von Manuel Göttsching höre, dann sehe ich wieder das Bild vor mir – aber vor allem spüre ich das Bild, ich erinnere mich an es.

Das Wandbild hier in Lübeck scheint ein ähnliches Grau zu haben und ebenfalls geometrische Flächen, die aneinander stoßen. Die Malerei reibt sich an der Form, die Farbe fleckt und die Kanten sind sichtbar, aber nicht scharf. Als würde sich da etwas behaupten, das sich nicht in eine Form zwingen lässt. Ein Dialog mit dem Modernismus wurde Alexander Wolff nachgesagt. Zu sagen haben sich die beiden sicherlich viel, der Modernismus und Alexander, aber wohl auch im DISAGREEMENT, in der Berührung von Grenzen, der Konturierung gegenläufiger Vorstellungen und der Frage: What Then Is This Method of Building Audio-Visual Correspondences? Das ist eine Frage, die eine Reihe von Bildern aus der Kooperation von Matt Chambers und Alexander Wolff betitelt. Elemente des Wandbildes sind 29 Ibeji-Figuren. Sie stammen aus Westafrika. Die Yoruba glauben, dass die Seele unteilbar ist und dass Zwillinge mit ein und derselben Seele auf die Welt kommen. Wenn einer der Zwillinge stirbt, wird eine Figur angefertigt, die dessen Seele beherbergt. Die Figur bleibt eng bei der Mutter, wird gewaschen, gehegt und gepflegt. Das Ding ist untrennbar verbunden mit dieser Familie. Es lebt mit ihnen, ruft Handlungen hervor, ist ein Element, das etwas hervorbringt, indem es BEHANDELT wird. Nebenbei steht es auch noch in zwei Realitaeten: einer konkret physisch-materiellen und einer nur mental zugaenglichen. Wie wir? [Esse est percipi – To be is to be perceived]

Besucher und Objekt begegnen einander und beginnen eine
Art Tanz. Ich komme gedanklich immer wieder auf einen Text
von David Joselit zurück: Painting Beside Itself. Darin schreibt
er über diesen Bedeutungszusammenhang, den ich schon mal
erwaehnt hatte. Er beschreibt Malerei als Teil eines Systems und
führt verschiedene Künstler an, in deren Arbeiten ein System aus
mehreren Elementen aufgebaut wird, so dass die immer schon
gegebene Vernetzung der Malerei selbst sichtbar wird. Zum Beispiel
bei Stephen Prina, Wade Guyton und Jutta Koether. Eine Stelle
des Textes gefällt mir besonders gut: "Three lecture performances
accompanied the exhibition in which Koether moved around and
even under the wall that supported her canvas–her body and the
bright anger of her recitation of collaged text furnished a frame
for the canvas. The painting's own presence as a personage – or
interlocutor – was further enhanced by strobe lights flashing onto it
in different configurations during these live events AS IF PAINTING
AND PAINTER HAD ENCOUNTERED ONE ANOTHER IN A
CLUB." [11]
Let's dance.

Das ist für mich nun keine neue Situation, Das ist für mich nun keine
neue Situation,
schon mehrmals stand ich zu Ausstellungseröffnungen und schon
werde ich aus Gewohnheit wieder sagen –- des Berliner Künstlers
– Alexander Wolff zur Eröffnungsrede, und schon wäre man
auch bei einem Thema des Künstlers, jenem der Wiederholung.
„ Der ironische Weg zur Freiheit, so könnte man deshalb auch
sagen ist, ist die Wiederholung, Wiederholung ist dabei allerdings
nicht im kierkegaardschen Sinne als Übergang auf eine höhere
Stufe (von Unmittelbarkeit zu Geist) verstanden, sondern eher
umgangssprachlich als eine Abfolge von mehrfachen Vollzügen
eines Typs, hier: von Akten der Selbstbestimmung, in denen
Unmittelbarkeit und Geist immer wieder neu vermittelt werden.
Eben weil uns unsere innere Natur nie als solche durchsichtig ist,
sondern sich immer nur im Austausch mit der veränderlichen Welt
ereignet und als Potentialität eine Quelle möglicher Veränderung
bleibt, können wir nur immer wieder neu die Herausforderung
annehmen, uns im Austausch mit der Welt zu bestimmen."*(Juliane
Rebentisch) „Mit anderen Worten, der Geist ist keine Kamera,
die Realität aufnimmt wie sie durch die Augen erkennt, sondern
<u>auch ein Projektor de</u>r die eigene Realität wiedergibt" (Herbert

11 David Joselit, "Painting Beside Itself", in: October, Nr. 130,
Herbst 2009, S. 127.

Read)* und „demnach scheint es, dass der/die Künstler/in, nicht nur eine/r ist, der, die sich weigert, seine ihre innere Realität zu verleugnen, sondern auch einer und zwar aus eben diesem Grunde –, der/die imstande ist, mehr als andere Leute zu sehen, oder wenigstens mehr von dem besonderen Stückchen, an dem er/sie interessiert ist" (Joanna Field)** und ebenfalls wieder, „dass der/die Künstler/in, der/die glaubt, er/sie könne den ‚Originalzustand' eines Objektes bewahren, sich täuscht. Dafür ist die Beschaffenheit der menschlichen Vorstellungskraft zu expansiv und allegorisch. Man kann nicht länger an ein Objekt ‚denken', ohne dass sich die Gedanken ändern. Objekte waren nie mehr als Stichworte für eine vagabundische Vorstellungskraft. Kein Mantel, kein Flaschentrockner, keine Coca-Cola-Flasche kann dem Ansturm der Vorstellungskraft widerstehen. Die Metapher ist für die Vorstellungskraft so selbstverständlich wie Spucke für die Zunge" (Dore Ashton)***, und „ Die Erfahrung, die der Künstler im Kunstwerk macht, ist vielmehr die, dass die künstlerische Subjektivität das absolute Wesen ist, in Bezug auf welches jede Materie und jeder Stoff indifferent bleiben. Nun ist aber diese von jedem Inhalt losgelöste Form, künstlerisches Hervorbringen als formales Prinzip, nichts anderes als die absolute und abstrakte Wesenlosigkeit, die jeden Inhalt vernichtet und auflöst in der nicht nachlassenden Anstrengung des Selbsttranzendierens und der Selbstrealisierung. Versucht der Künstler nun, in einem Inhalt oder einer Glaubensgewissheit Halt zu finden, ist er bereits der Unwahrheit überführt, er weiß ja, dass die reine künstlerische Subjektivität die Essenz ist, die allem zugrunde liegt. Lokalisiert er seine Realität dagegen in der Subjektivität, so begibt er sich in die paradoxe Lage, das, was seine Essenz ausmachen soll, gerade in dem finden zu müssen, was eben keine Essenz hat, dem eigenen Inhalt als bloße Form. Seine Lage ist von radikaler Zerrissenheit geprägt, und außer dieser Zerrissenheit ist alles an ihm unwahr." Giorgo Agamben So und dann wären 5 Zitate zu Beginn als Block schon eingeworfen, die alles zumachten, aber in der Absicht Text zur Ausstellung und am besten noch die Ausstellung selbst zu öffnen, zu weiten. Dekoration des Funktionalismus - Dekor der Funktion hieß etwa eine frühe Ausstellung des Künstlers wofür ich den Ausstellungstext, was es somit einen sehr frühen Ausstellungstext von mir machte, der ich mich da in etwas hineinmanövriert sah , was einerseits schmeichelte, andererseits auch zeigte was die Kunst in der Lage war mit einem zu machen , der zugleich nicht alles von ihr erwarten konnte, aber mit großer wie treuer Sympathie etwa gegenüber der Malerei Richtung einer Position Null geschoben wird, von der aus der Blick wieder freikommt auf Dinge, die man schon so oft gesehen hat, die in ihrer

ursprünglichen Intention und spezifisch ästhetischer Vermittlung längst unsichtbar geworden sind und Zitat Paul Klee:„Das Auge ist so eingerichtet, es bringt Teil für Teil in die Sehgrube, und um sich auf ein neues Stück einzustellen, muss es das alte verlassen… Dem gleich einem weidenden Tier abtastenden Auge des Beschauers sind im Kunstwerk Wege eingerichtet (in der Musik dem Ohr Zuleitungskanäle- das weiß ein jeder – im Drama beides beiden). Das Bildnerische Werk entstand aus der Bewegung, ist selber festgelegte Bewegung und wird aufgenommen in der Bewegung (Augenmuskeln)." Oder Vincenzo Borghini." Bedenke auch, dass die Menge (der Betrachter, der Verf.) viele Augen und Köpfe umfasst , der eine sieht etwas, der andere denkt über etwas anderes nach, und was der eine nicht sieht, das sieht derjenige der neben ihm steht. So bemerkt der eine dies und der andere etwas anderes, und indem sie miteinander sprechen, entsteht aus vielen Einzelheiten, die an sich schon vollkommen sind, etwas umfassend Vollkommenes."
In einer Einleitung einer anderen Ausstellungseröffnungsrede fand ich die mögliche Publikumserwartung eines Vortrages eines Liedes, das ich zur Einleitung einer anderen Ausstellungseröffnung gesungen hatte, mit folgendem Einschub - mein gott jetzt singt er gleich – gut abgeschmettert, heute wiederum ist der Vortrag dieses Liedes durchaus angemessen, anhand mancher in die Ausstellung hineinragender Themen, sie werden sie gleich erkennen. Ein weiterer Verdacht wäre, das ich deshalb als Eröffnungsredner bei den Vernissagen von Alexander Wolff abonniert bin, wegen meiner Neigung Sätze nicht ganz zu Ende zu sprechen und dadurch Momente weiträumiger Interpretationen, jenen der präzisen Vorwegnahme überwiegen und dabei dennoch kaum zeitlich überziehe und würde man nun beginnen, diese Zitate noch enger zu verweben, Satzzeichen zu streichen, das zu straffen, dann stünde hier so was wie höchste Sympathie für das Umkreisen der Problemzusammenhänge, dieser immer doch Malerei als deutliche und ausdifferenzierte Sprache der Zeichen, denn „Was Natur vergebens möchte, vollbringen die Kunstwerke, sie schlagen die Augen auf." (Adorno)

* Juliane Rebentisch " Die Kunst der Freiheit – Zur Dialektik demokratischer Existenz " Suhrkamp 2011
http://en.wikipedia.org/wiki/herbert read
* ** Joanna Field: „On not being able to paint", Heinemann, London 1950
*** „A symposium on Pop Art," Art News, 1964/1965

Blanket / Cologne, 2012

Blanket / Cologne is pleased to present a solo exhibition by Berlin based artist Alexander Wolff. This is Wolff's first exhibition with the gallery.

Alexander Wolff engages with the possibilities and limits of abstract painting. Blending modes of painting, wall paintings and site-specific interventions, Wolff emphasizes on the handmade and the material through his use of various surfaces such as cotton, linen, home decorating fabrics, which he primes, bleaches, sprays and soaks with pigment, acrylic and dirt. Relying on experiments, errors and failures, the artist idiosyncratically intensifies the character of material and ultimately, reflects on the materiality and process of picture making.
Wolff's work goes beyond the vocabulary of historical abstraction, blurring the distinction between abstract image, gesture, and material, revealing his on-going commitment to the definitive sense of formally reduced composition and serial reproduction.

For his first exhibition in Cologne, Wolff makes reference to a work by Heimo Zobernig, shown in his first exhibition at Galerie Nagel in Cologne in 1990. A sculptural work in the exhibition is directly inspired by Zobernigs economic shelf, which Wolff expands on and further subverts by turning it into a tool for producing prints which are assembled in a wallpainting-like-installation, partly concealing the gallery space and connecting the shapes of the sculpture with the space through painterly means.
Looking back at Cologne's art scene of the 1990s and comparing this with his own experience of Berlin since 2000, Wolff creates a specific context for his own art practice and resonates his debut in Cologne by focusing on the gesture of exhibiting a shelf, an object representing discourse and documentation. Wolff further reflects on printed matter as a productive and reproductive (artistic) medium. As histories are captured in books, he extends his research about the construction of history by including a kind-of monographic overview of his work under the laconic title "Painter Biographies", divided into four standard formats provided by a print-on-demand web based publisher.

Federico Bianchi Contemporary Art, Milano, 2013

Federico Bianchi Gallery is pleased to announce Alexander Wolff's third solo show in the gallery, opening on October 3th, 2013 at 6.30 p.m. in Via Imbonati 12, Milano.
Alexander Wolff's paintings continually try to disintegrate the traditional process of painting, or invent new possibilities to engage with the dialogue between the canvas and the paint itself. Focusing on the primary conditions upon which picture-making depends, he tries to analyze the most basic circumstances that produce whatsoever form.
The exhibition brings together works from the last two years, out of which some have been created during the artist's 2-year stay in Los Angeles. There he started experimenting with the use of fabric dye that gets thrown or poured directly on the wet canvas, resulting in a paint application that is completely integral to the fabric fiber. The paint becomes one with the canvas, the material of the canvas, cotton or linen, which is at the base for the artistic formal decisions, becomes inseparable with the design. In a further continuation of the relation between these two elements, Alexander Wolff has begun to take apart the succession of processes that generally constitute a painting, and to make works where the sewing together of singular pieces into a whole canvas becomes intermixed with the application of dye, or the use of the fabric itself as a printing device or brush.
At the base of these experiments stands the examination of the languages of painting as a whole and the reflection about the conditions for the occurrence of a specific aesthetic: reductionist or gestural, figurative or abstract, decorative or functional, representational or concrete are categories increasingly insufficient and limited for encountering and contextualizing a work of art. For Alexander Wolff the myth of creation and the ground for decisions are more connected with intention and intuition, which are in every case specifically situated in a cultural and historical context.
Also in the exhibition will be shown the video "Churches on West Adams Boulevard", which the artist also produced in Los Angeles over the course of 2011 and 2012. The 3 1/2 hour long piece is a study of architecture and interior design along the 6-mile long street in the L.A. neighborhood of West Adams. It is a portrait of spiritual America and its multifaceted appearances, as well as of an area with a specific history and a distinctive aestethic somewhere between improvisation and communal identity.
Furtheron a new series of publications of the artist will be shown under the title "Painter Biographies", for which Alexander Wolff has designed a bookshelf based on a sculpture by Heimo Zobernig from 1990. The "Köln Skulptur" serves as a printing plate for the curtains which make the backdrop of the exhibition scene and reflects the interrelations of art history and printed matter.

Kerstin Cmelka
Gestalten und Versionen

Text zur Ausstellung Galerie Anne Mosseri-Marlio, Basel 2013

Wie gehen wir damit um, wenn künstlerische Äußerungen sich kopieren und dabei ihr Medium wechseln? Wenn ein Objekt ein Bild wird oder ein Foto eine Malerei, eine Performance ein Abzug?
Alexander Wolff verwendet in seiner Ausstellung grafisch-malerische Vervielfältigungsmethoden.
Dabei werden beispielsweise die Einzelteile einer Skulptur als Druckstöcke benutzt, um damit modulartig auf Stoff zu drucken. Diese einzelnen Bestandteile wechseln nach dem Druckvorgang ihre Gestalt und werden zu einer modernistischen Skulptur umgebaut, die sich auch als Display und Aufbewahrungsort von Büchern, Zeitschriften und Musikträgern des Künstlers zeigt und diese wie ein Sender aus der Ausstellung hinaus in die Welt verbreitet.
Oder: Eine Siebdruckvorlage wird wiederholt auf eine, auf dem rauen Straßenboden liegende, vorher getönte Leinwand durchfrottiert, hernach das aus diesem komplexen Oberflächenrelief entstandene Druckergebnis zu einem Bildträger auf Keilrahmen geglättet.
Oder aber: Die Wirkung von Textilfarbe, Schablonendruck und Monotypie wird auf kleinen Stücken Leinwand getestet, die vielversprechensten Stoffstücke daraus dann mittels eines Patchwork-artigen Nähverfahres zu einer neuen Bildkomposition geordnet.
Sowie: Druckformen verschiedener Art werden mit Farbe eingewalzt, mit Leinwandstoff zu dreidimensionalen Objekten gefaltet, mehrmals durch eine Wäschemangel gepresst und ergeben, wieder aufgefaltet, ein Zeichnung, die, mit Schnitten und Nähten als zusätzliche Kompositionsparameter aufgeladen, ein Bildarrangement aus abstrakter Malerei, Ornament und einer LSD-Variante von Trompe l'oeil generiert.

Was ist hier eigentlich der Druck und was der Druckstock? Was ist die Form und was ihr Träger? Die Skulptur zum Beispiel ist die Druckform für ein Bild/einen Vorhang, oder aber, der raue Straßenasphalt ein öffentlich zugängiger Druckstock, der dann

auf ein weiteres Werkzeug, das belichtete Sieb, trifft. Ist in dieser Konsequenz die fotografische Vorlage für diesen Siebdruck - ein Foto der Bäume vor Alexander Wolffs Atelierfenster und eines von einem Badeschwamm auf seinem Wannenrand - nicht auch als eine Coverversion seiner nächsten Umgebung, seiner Realität zu sehen und so die Welt auch als eine Art Druckform für seine künstlerische Äußerung zu verstehen?

Kommen wir aber erst einmal dazu, was eine Coverversion überhaupt ist:

Ein musikalisches Cover imitiert ein bestehendes Musikstück. Dabei kann es von Interesse sein, dass mehrere Varianten eines Liedthemas gleichzeitig existieren oder aber, dass das Cover in einem kompetitiven Verhältnis zum Original (oder zu einer vorhergegangenen Version) steht, es sich wie ein Deckel auf das vorige drauflegt und es damit nicht nur überdeckt, sondern auch ablöst. Immer ist ein konstituierender Aspekt des Covers der, dass dem Rezipienten das Original des Liedes bekannt ist, denn anderfalls können wir die Coverversion gar nicht erst erkennen, geschweige denn beurteilen, ob sie nun an die Qualität des Originals herankommt oder nicht.

Dieses hierarchische Moment hebt Alexander Wolff in seinen Coververfahren völlig auf. Wichtiger erscheint ihm die erst erwähnte Möglichkeit, nämlich die, möglichst vielfältige Varianten einer Form zu produzieren.

Die klassische Druckgrafik zählt die Prinzipien Ab- und Durchdruck (Monotypie, Kontaktkopie, Serigrafie) zu ihren einfachsten Methoden, die daher erst spät als seriöse künstlerische Mittel in ihren Tenor aufgenommen wurden, aber auch den größten technischen Variantenreichtum aufweisen können. Wolff erforscht diese grafischen Grundtechniken, indem er mit ihnen experimentiert und immer wieder neue, komplexe Herstellungs- und Kompositionsstrukturen aus ihnen entwirft, die vorwärts und rückwärts springen sowie sich in alle Richtungen und Ebenen ausbreiten und aus jeder Vervielfältigung wieder ein Unikat machen können: Bildgründe werden mit Pigmentierungen vermischt, Druckverfahren Schicht für Schicht oder alle auf einmal, synchron, in einer choreographischen Anordnung angewandt, unter- oder oberhalb der Druckebene werden dazu malerische Techniken eingesetzt, selbst sowie kommerziell bedruckte Textilien appliziert, Nähte mit Streifen in Beziehung gesetzt, die Leinwand zweimal gedreht, die Wand

oft ebenso bearbeitet wie das Bild, das auf ihr hängt, selbst
eine Skulptur im Raum wird Teil eines Bildes und umgekehrt
und sogar im Fenster hängen welche, durch die man auch noch
durchsehen kann und so die Welt als Form, die man sich nur
nehmen muss, in den Ausstellungsraum holen kann. Wie ein
materialkundiger Stoffhersteller, Couturier, Maler, Druckgrafiker,
Bildwissenschaftler, Feng-Shui-Meister, Bühnenbauer,
Werkstattleiter, Pionier der Grafik wendet Wolff seine Techniken
gekonnt und perfektionistisch an, geht nach vorne und zurück,
gleicht unten aus und macht dann oben noch was dazu, hat durch
viele Versuche sein Material und seine Medien gut kennen gelernt.
Kommt ein Fehler durch sein Netz, dann nimmt er ihn mit offenen
Armen auf, macht ihn schnell zum wichtigsten Teil seines Werkes
und entwickelt gleich eine neue Technik für ihn, die im nächsten
Arbeitsvorgang Schule machen wird.

Wie bei modernen Volksliedern - etwas, das es eigentlich
gar nicht mehr gibt, aber Alexander Wolff macht – gibt es
hier ein Nebeneinander von immer wieder neuen, einander
austauschenden, sich selbst kopierenden und aneinander
abreibenden, eins aufs andere abdruckenden Coverversionen, die
hierarchielos, aber miteinander verbunden existieren und ihre
Schönheit bereit stellen. Dabei wird die Frage, wer zuerst da war
und wie man sich so messen kann, zugunsten von Herstellungs-
und Aktivierungsprozessen von Ideen und ihren Formen in den
Hintergrund gestellt.
Denn jeder weiß, wie die Maserung einer MDF-Platte aussieht und
die meisten haben auch schon mal Kartoffel- oder Möhrendruck
gemacht, eine Münze unter ein Blatt Papier gelegt und ihre
Oberfläche durchschraffiert. Obwohl Alexander Wolff ungeheuer
Kompliziertes und Komplexes damit machen kann, scheint es hier
aber nicht einzig darum zu gehen, diese Methoden und Techniken
zu propagieren und auch nicht unbedingt darum - wie ein Nerd
- aufzuzeigen, dass man sie besser beherrscht als alle anderen.
Vielleicht aber ein wenig darum, mit großer Geste zu beweisen,
dass es in der Kunst nicht darauf ankommen kann, wer nun einen
passenden Deckel für ein gerade offen dastehendes Kunstwerk hat,
um mit seiner neuen Version davon die alte ausstechen zu können.
Vielleicht sind die Ideen ja eh alle da, vor unseren Fenstern und
wie ernsthaft wir um sie werben, wie empathisch wir mit ihnen in
Kontakt treten und wie mutig wir sie Gestalt werden lassen, darauf
kommt es an.

Alexander Wolff
"day cracks & night shadows"
Galerie Johann Widauer, Innsbruck, 2014

Der in Berlin lebende Künstler Alexander Wolff (* 1976 in Osterburg) zeigt bereits den ersten Schritt in die Ausstellung "day cracks & night shadows" als einen möglichen Schritt zuviel, als einen durch einen Patchwork-Vorhang, der erste Erwartungshürden verschieben, wenn nicht gar umstoßen kann. Er beschreibt den Moment eines Ein- und Austretens aus der Erfahrung, als Wechselspiel von Teilhabe und Distanz, von Immersion und Reflexion. Schon ist ein Prozess in Gang gesetzt, man bekommt einen Vorgeschmack des Entdeckens, man sieht die Arbeiten in ihrer Form den sie umgebenden Raum, vom Boden bis zur Decke aufgreifen.

Das Erlebnis der Kunst scheint hier als kreisförmiger Prozess, der von jedem beliebigen Punkt in der Ausstellung aus starten kann – wobei die möglichen Punkte Praxis, Geste, Diskurs, Dokumentation, Reproduktion sind oder einfach für ein Nachdenken über Malerei durch die Malerei stehen. Wolff reflektiert nicht nur die materiellen Bedingungen wie Farbmaterial, Farbe, Bildträger oder Pinsel, Bildformat oder Malverfahren, oder in den Straßenspuren, den titelgebenden "cracks" als lose verteilte Poster den Berliner Entstehungsort der Arbeiten und in Folge den Ausstellungsort jener hier in Innsbruck (ehemaliges Dekorgeschäft), er thematisiert zudem das vertrackte Abhängigkeitsverhältnis von Bildträger und Farbauftrag.

Der Maler inszeniert mehrere unterschiedliche Arbeitsstadien der Bildentstehung gegenläufig und konfrontiert diese mit ihrem eigenen Kombinationspotenzial. Die Bilder sind wie in einer neuralgischen Zwischensituation, wo der Bildträger – Stoff als Material selbst, durch den Farbauftrag sichtbar wird, und sich der Bildträger Leinwand sich aus Einzelteilen zusammen setzt, während sich der Farbauftrag über mehrere zusammengenähte Einzelteile zieht, ehe er wiederum mit anderen Einzelteilen zusammengefügt werden kann.

Der eigentliche Farbauftrag steht so in keinem Bezug mehr zum Format und wird doch als formbestimmendes, sich selbst abbildendes, konstruktives Element sichtbar. Er belässt es aber keineswegs in einem analytischen Verhältnis, welches so gar kein Gegenüber in der Welt außerhalb der Malerei kennen will, nur sich selbst zeigt und Malerei ausschließlich als Tätigkeit

und Produkt dieser Tätigkeit in der künstlerischen Produktion zum Gegenstand der Reflexion erhebt. Nein, gegenteilig, er zeigt sie allererstens fragil um sie und alle an ihrer Präsentation beteiligten Elemente, Kunstwerke, Architektur, Display-Verfahren, Referenzrepertoires, Hängung, aber auch die Dokumentation im Anschluss einem kontinuierlichen Fluss des Wandels freizugeben und sie dann in neue und meist nicht mehr vermutete Beziehungen zueinander treten lassen zu können.* Dass es die Auswahl der Ausstellungsexponate, die Anordnung und die Inszenierung dieser ist die überhaupt Bedeutung produzieren, die Ausstellung dabei auch das zentrale Medium innerhalb des Feldes der Kunst ist, über das Diskurse vermittelt, aber auch Kunstgeschichten vor dem Hintergrund des jeweiligen Lokalkoloriten geschrieben werden können, bündelt die in "day cracks & night shadows" gezeigte „Köln Skulptur". Als skulpturale Referenz an Heimo Zobernigs erste Galerie-Ausstellung in Köln 1990, enthält sie historisierende Katalogproduktionen aus der Zeit, einige Künstlerinnen Magazine, bzw. eigene print-on-demand Produktionen bereit und stellt sozusagen die die diskursive Referenz konstituierenden Parameter und deren Dokumentation mit aus. Noch viel wichtiger und nicht außer Acht zu lassen ist weiters, dass das zeitlich und räumlich begrenzte Medium der Ausstellung nicht immer nur an eine bestimmte institutionelle und diskursive Situation gebunden ist, die stets im Hier und Jetzt verankert ist und von den Rezipienten mitgetragen wird, auch deren medialer Niederschlag und die Nachrichtenzirkulation in Kunstkreisen darüber in einem zeitlich undefiniert anhaltendem Danach formt die Rezeption, auch wenn diese Faktoren von Alexander Wolff dafür in "day cracks & night shadows" einmal mehr komplett neu, mit noch offenem Ausgang angelegt sind.

Christian Egger

*„Dass eine Auseinandersetzung mit dem Zusammenhang zwischen Präsentationsbedingungen, Kunstbegriff, Rezeptionshaltungen und Gesellschaft im Medium der Kunst selbst statthaben kann, verweist nämlich auf eine tiefgreifende Veränderung im Kunstbegriff, die das möglich macht."

Juliane Rebentisch - Theorien der Gegenwartskunst zur Einführung, Junius, 2013 Hamburg

Mitzi Pederson - Laurie Reid - Alexander Wolff
Et Al., San Francisco, 2014

a scattered poem sounds good.

once i wrote a paper
with a friend
based on something i can't remember right now,
where we both wrote sequential random sentences or maybe evenly
divided what we wrote somehow
 - but basically it was kind of half-blind writing - or maybe we
pulled out each sentence from a hat...

i stayed at home today
it's finally quiet at my house
warm winter, no snow
3 kids getting ready for school
a bit of commotion
they were pretty quiet
everyone is pretty sleepy in the morning

the surprise of what will happen
how to say that in a press release
as opposed to what we wrote

kids will come to see our show
bringing me back to the present, explain or communicate it in some
way

paintings would get sent from NY
starting from the wall and moving to the center,
haven't moved beyond the adjective: a rectangle shape, not too
long, but not like a square
the entrance is on a short end...descend the stairs and then
enter the rectangle
a cool long narrow awkward stairway
straightforward, clean, white and bright
contrast
chinatown

do studio-drop-bys
much easier in dialogue
other ways to build bridges or connections than by

looks/shapes/aestetics
not necessarily building them but suggesting them
golden gate
other thans
golden than

just throwing out another idea!
fragmented. is there a connection?
maybe the connection on your end slowed? a connection in that it's open, like
or - maybe i misunderstood
open like the process
slow connection
slopen
slowing down to
be with it
mix with it

longing for...
its evening here, and
i need the dictionary sometimes
evening and morning thoughts and spaces
like working at night
all exist together equally as is with no direction and with no non-direction
letting tangents move us around for a bit
make some work and fun
immingle, underlying,
making it to the studio.

get along well with men
prefer women
male vibe
that vibe
be male
mixed vibes
macho art
(flex)

Margaret was kind of the starting point. I met her at the "Miss Read" pubication fair, she had her booth next to our magazine, in Berlin, and she was so sweet to tell Laurie about my coming to CA and that we could make a show happen and you Laurie made it happen. Thanks, Margaret!

www.ingramcontent.com/pod-product-compliance
Lightning Source LLC
Chambersburg PA
CBHW070426180526
45158CB00017B/812